THE GROWTH OF THE BOOK-JACKET

There is nothing more fit to be looked at than the outside of a book. It is, as I may say from repeated experience, a pure and unmixed pleasure to have a goodly volume lying before you, and to know that you may open it if you please, and need not open it unless you please. It is a resource against *ennui*, if *ennui* should come upon you.

Thomas Love Peacock, *Crotchet Castle*, 1831

I gather that to the many other arts has now been added the art of the book-jacket, and that there is an exhibition of it in the Victoria and Albert Museum. I doubt whether, if I were in England, I would visit this, for I have in recent years seen many such exhibitions. To stand by any book-stall or to enter any book-shop is to witness a terrific scene of internecine warfare between the innumerable latest volumes, almost all of them violently vying with one another for one's attention, fiercely striving to outdo the rest in crudity of design and of colour. It is rather like visiting the parrot-house in the Zoological Gardens, save that there one can at least stop one's ears with one's fingers, whereas here one merely wants to shut one's eyes.

Sir Max Beerbohm, *The Observer*, 1949

Charles Rosner **The Growth of the Book-Jacket**

With 226 Illustrations

1954 · Harvard University Press · Cambridge · Massachusetts

by the same author

PRINTER'S PROGRESS 1851-1951

A Comparative Survey of the Craft

of Printing

The first International Book-Jacket Exhibition was held in the Victoria and Albert Museum, London, in 1949, on the instigation of the author, and following on his cooperation with Mr. Peter Floud, Keeper of the Circulation Department. The former's own collection was supplemented by a large number of additional jackets collected by the Museum, amounting in all to about 8,000. Out of this total the joint organisers selected 460 contemporary book-jackets, deemed to be worthy of hanging on the walls of a national museum.

After the showing in London, the Exhibition toured the larger English provincial centres; and, after revision, it was shown in museums in Switzerland, Germany, the Scandinavian countries and Holland. As an accompaniment to the London Exhibition, the author was asked to write a brief survey, which was published by Her Majesty's Stationery Office on behalf of the Victoria and Albert Museum under the title of *The Art of the Book-Jacket*; and, on the occasion of the first Continental display in Zurich, a German version was printed in the catalogue of the Kunstgewerbemuseum.

The international interest in the exhibits, both of the press and public, was far in excess of expectation, and has seemed to justify the publication of a pictorial survey and documentation, registering the editorial and artistic level to which this recent newcomer to advertising art can rise.

Is the loose *book-jacket* a successor to the *book-cover*, which was glued on to the book itself? The ultimate conclusion is that as the book cover formed an integral part of the book along the centuries, its history belongs to that of the art of the book. The loose *book-jacket* started life entirely on its own, unprejudiced by the achievements in the field of the *book-cover*, and, combined with its protective function, its main purpose is to act as a piece of publicity.

There were two equally justifiable methods of arranging the 226 jackets from twenty-four countries, reproduced in this book: either in groups, by country of origin, or by subject-matter. Both methods have their advantages and disadvantages. The first was chosen after due consideration since it seems to reveal more clearly the general standard of this form of applied art, *as a whole*, country by country, and it was also the method adopted for the first International Book-Jacket Exhibition. Nonetheless, in order to assist those publishers, designers and students who wish to make an international comparison, according to subject, in addition to the index of illustrations, listing designers and publishers, translations of titles and type of book, a second index lists the reproductions under such headings as Fiction, Biography, Poetry, Anthologies, Non-Fiction, Art, Travel, etc., country by country. The selection was planned to show the greatest possible variety of categories from each country, and it is not surprising that Fiction predominates. As often as possible, jackets for translations of well-known works have been included, to demonstrate how a country other than the author's presents his book.

The essay accompanying the pictorial symposium has three aims.

First, it surveys reports about early book-jackets and the attitudes prevailing at the time. Once the designer's and collector's present interest in the book-jacket lifts it out of the sphere of ephemera, it might be found worthy of scholarly attention, and no doubt further methodical and thorough research would unearth hitherto unknown historical facts.

Secondly, an attempt has been made to outline the intricate problems facing publisher and designer in deciding on the right jacket for different types of books, from the commercial and artistic point of view, and to convey the great number of considerations involved. It is hoped that this will result in an appreciation and understanding

of the jackets reproduced and enable an assessment of the degree to which they have fulfilled their task. It is hoped, too, that this clarification will be helpful in inspiring individual conceptions. Naturally the reader must look to other sources for instruction on the varied and manifold technical methods, such as typography, calligraphy, wood-engraving, scraperboard, lithography, photography, etc., with their numerous combinations, which are synonymous with the design and reproduction techniques of any other items of printed commercial art.

Thirdly, the major trends of book-jacket design in leading countries have been summarised, to give a background to the pictorial part which consists, with few exceptions, of book-jackets of the post-World War II period. This was felt to be relevant as, to the best of the author's knowledge, no museums hold either national or international collections of book-jackets. But for a few comprehensive and longstanding national collections in Germany, it seems that the fashion for their collection in other countries largely followed on the International Book-Jacket Exhibition of 1949.

The willing way in which publishers, designers, printers and others furnished information and material for this book was notable; particular thanks are due to Mr. Thomas Warburton of Manchester, who gave access to historical material; to Mr. Peter Floud, of London, and Dr. Willy Rotzler, of Zurich, who showed great interest in every aspect of the subject and gave valuable advice; and to Mr. Alvin Lustig, of New York, who has expressed, through his jacket for this volume, the meaning of the *art* of the book-jacket.

Great Britain

Over a century ago, Thomas Love Peacock wrote that there was nothing more fit to be looked upon than the outside of a book. «It is, as I may say from repeated experience, a pure and unmixed pleasure to have a goodly volume lying before you, and to know that you may open it if you please, and need not open it unless you please». In his day, however, it was possible to indulge in the luxury of contemplation. Today there is little time for «window-gazing», and in a highly competitive world one of the vital functions of the outside of a book is to attract the eye.

The book-jacket had a humble beginning. It was simply a dust-wrapper which was used by London booksellers to keep their wares free from smut and fog. In our day this English invention has become an integral part of a book. It is not strictly true to say that the first book-wrapper was made of paper, as cardboard covers for the preservation of fine leather and watered silk bindings were in use before the first known book-jacket, and booksellers also protected their stock with plain sheets of very poor paper loosely wrapped round the covers of the books. It was not until comparatively well into the nineteenth century that book-jackets as we know them today began to be printed and specially designed.

What of the early book-jackets that have survived in Great Britain? Mr John Carter, the renowned book-collector, stated in the *Publisher and Bookseller* in 1932, that the earliest specimens known to him were:

«Bunyan. *The Pilgrim's Progress*, illustrated by Charles Bennett, 1860 (Longmans). In a pale buff wrapper, printed in red; title and ruled bands on spine, back blank, front with titling on a scroll and a large woodcut from the book itself, besides all other normal particulars, including the price and the date.

«Dickens. *Edwin Drood*, 1870 (Chapman and Hall). Previously looked upon in the United States, where the interest in early book-jackets was more intense than in Great Britain, as the earliest English book-jacket*. In a buff printed jacket (plain back, if I remember right). This was a copy of the earliest issue of the book, which places the jacket before 1872 at the latest.

«Lewis Carroll. *The Hunting of the Snark*, 1876 (Macmillan). In a grey printed wrapper, dated, and carrying on the back advertisements of the two *Alice* books. This is the earliest case known to me of a jacket bearing advertisement matter». This jacket is reproduced in its entirety on page X. The back carries a list of works of Lewis Carroll, an unusual practice in those years.

Two years later, in 1934, Mr Carter reported that an even earlier specimen had come into his hands:

«Heath's *Keepsake*, 1833. This wrapper, which was in place on a copy of the book in question, is of pale buff paper, printed in red. The front carries the title and description and publisher's imprint (Longmans) within a formal frame. The spine is blank. The back carries advertisements of other Longmans publications, concluding with Turner's 'Annual Tour' which 'will be published on Nov. 1st, 1832'.» By no means of primitive design (see page X), it was issued within seven years of the first use of cloth for casings, and only four years after Heath's introduction of watered silk. Liability to soiling had called for the slip-case, and apparently it motivated the initiation of the dust-wrapper.

Heath's *Keepsake*, therefore, would appear to be the first known example of the modern book-jacket.

* Reproduced in the Catalogue of the Second Annual Exhibition, Book Jacket Designer's Guild, New York, 1949

Between 1876 and the end of the nineteenth century, dust-wrappers appeared on children's annuals, which are more or less a borderline case between book publishing and magazine publishing. It is not improbable that the motive in creating these wrappers was to present young readers with volumes similar in appearance to contemporary magazines. They appear to have had little influence, however, in spreading the use of jackets on books of other kinds. Until the early nineties, publishers and booksellers continued to cover their books with nondescript pieces of paper, sometimes with a window cut out of the spine to display the title or with plain transparent glassine over the window.

As glassine is transparent, it was possible to show the pictorial covers on the Victorian «yellow-backs», which date from the eighteen-fifties, and it is interesting to surmise just how much influence these exerted on the evolution of the pictorial jacket.

The following summarises the development which took place in the last decade of the century:

Plain transparent glassine;
Kraft paper with heavy block lettering;
Kraft paper with silhouette design;
Smooth paper with black and white picture drawn in line;
Imitation art paper with three-colour picture (sometimes in two colours).

«As far back as 1896», writes Mr A. D. Marks, who worked in the early years of this century with Fisher Unwin, «at least one publisher realised that book-jackets were 'more than a piece of paper'. At that time, the late T. Fisher Unwin was adorning his fiction with a design illustrating either an incident or a character in the story, and this was produced in black silhouette on a green kraft paper. These pictures were not by any front rank artist, but were designed by a junior member of his staff who possessed enthusiasm, but little else.

«In 1906, Fisher Unwin published John Oliver Hobbes' novel, *The Dream and the Business*. The wrapper design in three colours on art paper was by Aubrey Beardsley». (The date of his death was 1898). «True, Beardsley was not commissioned to do the design for this book. The design used had been bought for general advertising purposes, and as it was his famous poster, 'The Girl and the Bookshop', it was, in a moment of whimsy, thought to fit the title, if nothing else.

«All this spurs me to claim T. Fisher Unwin as the pioneer in decorative jackets for fiction».

It would, however, appear that the earliest decorative wrapper of a book published in England was on Kipling's *Just So Stories* in 1902. According to an article by Mr John T. Winterich in *The Publisher's Weekly*, New York, 1937, a journal which has for many years published articles relating to early book-jackets, «the picture on the front wrapper reproduced an illustration from the book and differs entirely from the cover design, the back wrapper advertising other books of the same publisher».

In 1904 or 1905, McLagan and Cumming of Edinburgh printed a coloured jacket for a children's book by Walter Crane, and another for a children's book of verse by Kate Greenaway.

From about 1906, this firm printed coloured jackets for children's books by flat-bed lithography, in full colour (five to nine printings). They were published by Chambers, and in about October of each year a volume was brought out for the Christmas gift market.

Many of the earlier pictorial jackets relied on illustrations taken from the inside of the book. Publishers then paid so little attention to the quality of original book-jacket designs that, for instance, in a picture appearing on the jacket of one of W. W. Jacobs's early books, the sailor's feet were on the wrong legs.

But by 1928 the book-jacket could command the attention of so eminent an artist as Sir William Orpen. When the original of his design for H. G. Wells's *Mr Blettsworthy on Rampole Island* (see page XI), commissioned by the late Ernest Benn, was lost, he insisted on a second fee for his copy, and in all he received two hundred guineas. Perhaps it is not surprising, therefore, that there is now a «market» in book-jackets, and in antiquarian booksellers' catalogues, items which are listed with the original dust-wrappers fetch a higher price than those without.

«Blurbs» do not seem to have appeared on early jackets, although reference to the publishers' other titles was made in the space used for this purpose today. Mr John T. Winterich, in his *Publisher's Weekly* article, said that

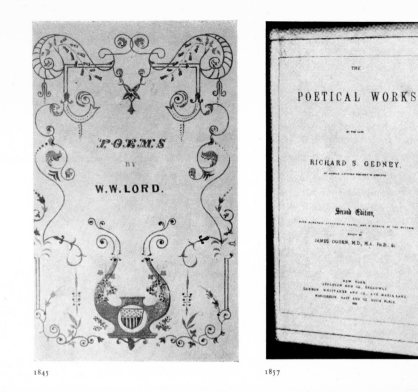

1845

1857

SOME OF THE EARLIEST KNOWN BOOK JACKETS: USA

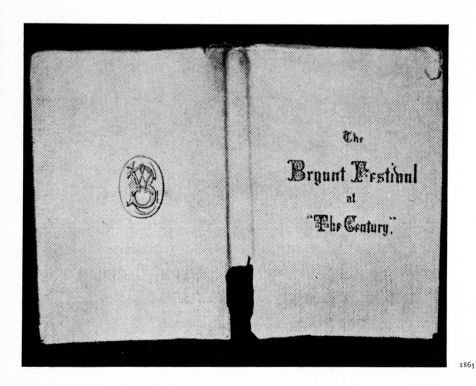

1865

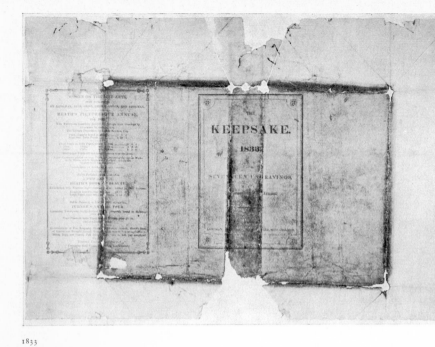

1833

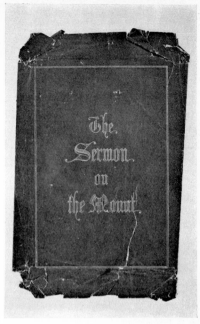

1870

SOME OF THE EARLIEST KNOWN BOOK JACKETS: GREAT BRITAIN

1876

1897

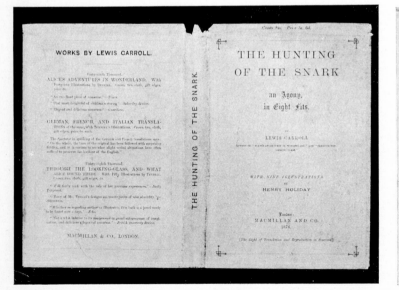

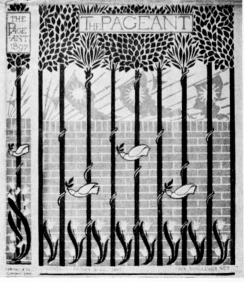

1896

1900

SOME OF THE EARLIEST KNOWN BOOK JACKETS: GREAT BRITAIN

1902

1906

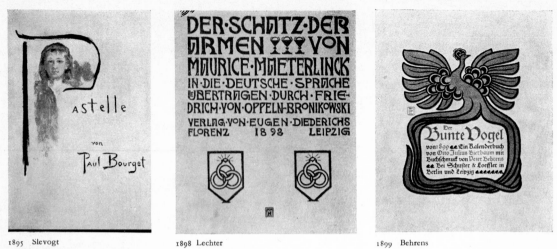

1895 Slevogt 1898 Lechter 1899 Behrens

SOME OF THE EARLIEST KNOWN BOOK JACKETS: GERMANY

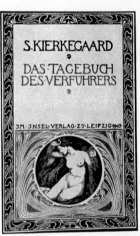

1900 Ehrmann 1902 T. T. Heine 1903 Tiemann

1904 Vogeler 1906 E. R. Weiss 1910 F. H. Ehmcke

he could find no early use anywhere of a «blurb»; and in the thirties, in *Spalding's Quarterly*, issued by Spalding and Hodge, Mr Vincent S. Smith wrote: «Herbert Jenkins, shortly after 1910, issued a pictorial wrapper carrying an advertisement or 'blurb', as it is termed, having direct bearing on the book covered».

As, in spite of thorough inquiries, no more relevant facts than these could be found by the organisers of «*The Art of the Book-Jacket Exhibition*» held in London in 1949, their original plan to include historical material had to be abandoned, owing to its scarcity.

It was not until 1932 that any serious consideration to the question of book-jacket collecting appeared in print. In that year, Mr A. J. Hoppé read a paper to the Society of Bookmen which was subsequently printed in *The Publisher and Bookseller* of August 5th, and Sir Henry McAnally's article, «*Book-Wrappers*», was published in No. VI, April-June, of *The Book Collector's Quarterly*.

«The book-wrapper», wrote Sir Henry, «is relatively and absolutely an upstart, and a good number of people have not yet decided whether they wish to encourage it or not. The upstart itself has not yet attained to a settled name». He asked whether book-wrapper collecting existed in any purposeful way; and, if it was found to exist, why it should emerge, or even, possibly, be encouraged to emerge; and on what lines it might be expected to develop. What did the circulating libraries do? They had, of course, to face the vital question: What were they to do with their book-wrappers? Up to 1923 it was their practice not to keep any wrappers, but during that year the British Museum began to preserve all book-wrappers, not, however, in the books to which they related, but in separate bundles. By the end of 1930 the accumulation was judged to be out of proportion to any value that could be attached to the collection, and by the beginning of 1931 officials of the Museum stated that only a selection could be preserved.

Sir Henry thought that those individuals who were not bibliophiles were apt to look on book-wrappers as an unmitigated nuisance, only fit for the waste-paper basket. Quoting a case of Miss Rose Macaulay's novels and their purchase as a Christmas present, he said that one of the jackets was found to conceal a book by Miss V. Sackville-West! As for professed bibliophiles and their collecting of modern books, they tended to preserve the wrapper, but they did not regard themselves as book-wrapper collectors. As a wrapper could not be acquired without buying the actual book, it seemed improbable to him that there should be many collections of book-wrappers on their own. Book-wrappers did not appear as separate items in booksellers' catalogues or elsewhere, and book-wrapper collecting could be summed up at that date as «non-existent».

The only favourable thing he said was that the «blurb» might affect the desirability of collection, as it would always be interesting to see how an author was «blurbed» at different stages of his career. The collector might also be attracted by the change of wrapping design on subsequent reprints and different editions of an author's book. Nonetheless, he hoped that the First Edition Club, in whose journal his article appeared, would never stage an exhibition of book-wrappers.

Mr Richard de la Mare, in his Dent Memorial Lecture of 1935, «*A Publisher on Book-Production*», referred to the book-jacket as «that wretched thing, of which we sometimes deplore the very existence». As this seemed to be the attitude to book-jacket collecting early in the nineteen-thirties, it is understandable that only few specimens survive.

On the other hand, the lone voice of Mr Ralph Straus, the eminent literary critic, was heard as far back as 1924. «If you are a collector of modern books», he wrote in *T. P's and Cassell's Weekly*, «don't throw away these gay covers in which they are generally encased. One day they may be of considerable value. You smile! But I will give you my reasons... Yet how many preserve these jackets? I know of only one other collector besides myself. A few careful souls cut out the picture, if they are attracted by the design, and paste it inside the boarded covers, but in general it is looked at and thrown away. I am convinced that the jacket in some form or another will be required at future book sales, and perhaps some ingenious collector will devise a new plan for its preservation».

Following the 1949 showing of Book-Jackets in London, the author's account of early book-jackets, with an appeal for further information, appeared in *The Times Literary Supplement* (12th May 1950).

Commenting on Thomas Love Peacock's admiration for the outside of a book, the Reverend A. S. Bryant wrote: «I would like to think that when he expressed his feelings, he had in mind 'Forget me Not', published by R. Ackermann, which seems to be the original and inceptive book-jacket, for only so can Peacock's preference be understood. The mint copy before me with jacket of coloured engravings and the green ribbon attachment, inscribed by Lord Louth, contains a host of good things, among them Byron's first attempt at poetry—then known to be extant—written in his fifteenth year, but omitted by him from 'Hours of Idleness', 1807; and an acknowledgment of a bunch of flowers from Wordsworth, dated from Rydal Mount, 1829».

An illuminated book, *The Sermon on the Mount*, Gospel of Saint Matthew (artist, F. Lepelle de Bois Gallais), about 1870, is now in the author's collection (see page X). With its wine-red cover and embossed gold lettering—a repetition of the actual binding but for the colour of the paper—it is the earliest known English wrapper of a religious publication.

The author was allowed to inspect a book-jacket of *The Pageant*, 1897, in the possession of Mr Allan Wade, of Boscastle, Cornwall. With its three-colour printing in yellow, green and red (see page X), it appears to be the first known English pictorial book-jacket in colour. The jacket does not repeat the design on the cloth cover, and it carries the price of the book on the front lower corner.

The purist can decide whether a rejected sketch, completely executed for reproduction, can be considered to be a jacket from the historian's point of view. If it can, then Beardsley's jacket — designed between 1892 and 1894 for Sir Thomas Mallory's *Morte d'Arthur* and carrying the imprint of Dent & Sons, the old-established English publishers—would take preference even over the jacket for *The Pageant*. It was first reproduced in the Catalogue of the Second Exhibition of the Book-Jacket Designer's Guild, New York, 1949.

A jacket of *Books on Egypt and Chaldea* (Kegan Paul, Trench, Trubner & Co., 1902) was sent by Mr E. P. Warner of Cairo to the author (see page XI). It is an early specimen with the publisher's advertisements on the front and back cover, the title of the book appearing only on the spine. Through the courtesy of Mr W. W. Smithson of London, he was also able to inspect a wrapper of *Memoirs of a Surrey Labourer* (see page XI), published in 1906. The blurb is printed on the front of the jacket and is so far the earliest known English example.

The effects of the discouraging attitude of Sir Henry McAnally and others to book-jacket collecting is regretted not only by collectors, but by bibliographers. When Mr R. Toole Stott was engaged on the compilation of his *Maughamiana* in 1950, he wrote to ask if there was any evidence of a cancelled jacket for *Of Human Bondage*, as a few copies were believed to have got into circulation. Unfortunately the publishers have no particulars of its appearance, and Mr W. Somerset Maugham himself is unable to recall it.

USA

The quest for the early book-jacket in the United States was easier than in other countries. Not only was there interest in its past and future, but historians received full support from *The Publisher's Weekly*. Lavish space was given to original contributions, elaborate correspondence and controversial articles.

The earliest known American example of a protective wrapping is referred to by Mr John T. Winterich in his article in *The Publisher's Weekly* of 15th February, 1930. «I own an 'Atlantic Souvenir' for 1829», he wrote, «and have seen one for 1828, in which the book, bound in green decorated boards with cloth back, is enclosed in a four-sided pasteboard sheath, the front and back of which reproduce, on green paper affixed to the pasteboard, the decorations of the covers of the book. The parts of the sheath covering the spine and fore-edge of the book are blank».

In the Huntingdon Library, San Marino, California, there is a copy of William E. Lord's poems (see page IX), in excellent condition. It was published in 1845 and carries the original dust-jacket printed in three coloured inks.

Two rare items were reproduced in *The Publisher's Weekly* of 30th October, 1937 and 15th January, 1938. The wrapper on *The Poetical Works of the late Richard S. Gedney* (see page IX), bearing the imprint of Appleton & Co., 1857, is of particular interest as it was black-printed on pale blue glazed paper, *completely covering the book, spine,*

sides and edges. The Bryant Festival at «The Century» (see page XI), also published by Appleton and dated 1865, is notable. The printing on the covers of the book itself—the title lettered in red on the front cover and William Cullen Bryant's monogram on the back cover—is exactly reproduced on the thin brown paper jacket. It was evidently designed to protect a binding unusually perishable both in colour and material.

Some other early specimens are *Ballad Stories of the Affections*, from the Scandinavian by Robert Buchanan (New York, 1869); the book has an American imprint, but it was actually printed in England, and, according to Mr George T. Goodspeed in *The Publisher's Weekly* of 16th May, 1931, presumably the dust-jacket was also printed in England; Longfellow: *The Hanging of the Crane*, 1875, originally brilliant yellow buff, it has now faded to terra cotta, flimsy paper, entirely plain on spine and back and lettered on the front; and Joel Chandler Harris: *Uncle Remus: His Songs and Sayings* (New York, 1881), second issue, with press notices of the book, still encased in a jacket—the earliest departure from the primitive wrapper designed merely as a protective covering. The front of the wrapper does not reproduce the cover design, but the Church illustrations on page 90 of the book, with title, and sub-title, and the back carries an advertisement of «The Orthoepist».

The jackets of *Tributes to Longfellow and Emerson* by the Massachusetts Historical Society (Boston, W. Williams & Co.) and of *Proceedings at the Dinner given by The Medical Profession of the City of New York, April 12th, 1883, to Oliver Wendell Holmes* (New York, Putnam) are of stout grey paper, without printing except for title, publisher and date—1882 and 1883 respectively.

A Winter Holiday by William Hutchinson was published, apparently for at least semi-private distribution, at Providence in 1886. It is a pleasant and intimate account of a vacation in Florida and the West Indies, and it was encased in a white paper jacket, carrying on the front the words, «A Winter Holiday by Dr. Hutchinson». The jacket is dingy but entire, the book itself is in white boards, the most easily soiled of bindings, but the flimsy jacket has kept the covers in a state of mint whiteness.

The Shadow of a Dream by W. D. Howells (New York, 1890), is the earliest known USA *pictorial* dust-jacket, and Thomas Nelson Page's *On Newfound River* (Scribners, 1891), and 'Hop' Smith's *Tom Grogan* (Houghton Mifflin, 1896), were the first simple cover designs.

Book-jacket collecting had the same controversial passage in the United States as it had in Britain. The place of dust-jackets in the activities of book-collectors had for several years been a vexed question, according to Mr John Svan E. Kohn, writing in *The Publisher's Weekly* in 1937. Collectors, bibliographers and dealers had taken positions on either side. In general, no one preserved jackets up to about 1917; but no less keen a judge of books and literature than Paul Lemperley of Cleveland, who must have been collecting ever since the eighteen-eighties, never threw one away. Visitors to his library could be shown such items as his copy of *The Red Badge of Courage*, still mint in dust-jacket, precisely as it came from the publisher on his order in 1895.

Another collector of equal standing refused to have a dust-jacket in his library, though the standard of condition of his works was legendary. If you were to present him with a mint copy of say, *Ben Hur*, in the original dust-jacket, assuming it had one, he would wait politely till your back was turned and then hastily slip the jacket in the nearest waste-paper basket.

Competent students, when compiling bibliographies, added a description of dust-jackets. This growing practice induced Charles Beecher Hogan, in his exemplary bibliography of Edwin Arlington Robinson (1936), to give in his introduction his reasons for not doing so.

By the late nineteen-thirties, many rare book dealers were beginning to express their disapproval of interest in jackets. Others undemonstratively took advantage of the rewarding premiums which jackets frequently commanded. The presence of dust-jackets corresponds with the basic aim in the collecting of first editions: to preserve as nearly as possible the appearance of the book at the time of publication. Indeed, sometimes they are helpful or even indispensable in identifying the first edition of a book, and, as remarked in an American report of 1936, the dust-jacket is looked upon as true cloth of gold in the auction room. Its presence signifies, in general, a superfineness of condition in the book it encases, and the factor of condition continues to be the determining element in establishing values. If a book is excessively rare even without the jacket, it is inevitably far rarer with it. Every book

listed for sale at auction is a law unto itself; it will sell anyway, jacketed or not, but with the jacket it becomes for the moment the cynosure of the collecting world.

Germany and France

The history of the book-jacket is a more complex one as far as France and Germany, and indeed other Continental countries, are concerned, for here a distinction has to be made between book *covers* and book *jackets*. As covers were part of the book, their artistic evolution ran parallel with book-design; at times they reached a high level, and their history belongs to the art of the book. The late nineteenth century, however, saw the beginning of the use of pictures on covers *independent* of the inside design of the book, and there is ,therefore, justification for considering them within the history of early jackets, in countries where limp-covered books were predominant.

In a slim publication entitled «*Cover and Dust-Wrapper on the German Book,*» published by the Gutenberg Society in Mainz in 1951, Professor F. H. Ehmcke, one of the great early German book designers, summed up his own, and indeed what may be accepted as the German outlook on the relationship between cover and wrapper. He maintains that the forbears of paper cover and book-jacket must have been the modest cover which for 100 years was the usual dress of French literature, and indeed still is. The bright yellow paper with the bold Didot type displayed, in a strongly persistent manner, the author's name and the title of the book. It was a triumphant piece of publicity not dissimilar to the music covers and posters of touring musicians, items which were always successful in making their mark on the display boards, owing to their bold simplicity. It was in this way that the influence of publicity took possession of the outside of the book which, in its other aspects, remains conservative.

No doubt both book-cover and book-jacket can be classified as a sophisticated form of poster art. Both came to the fore in France with Toulouse-Lautrec and Steinlen; and in Germany Otto Eckmann auctioned his easel paintings, in Munich in 1894, as he wished to concentrate all his energy on the applied graphic arts.

The «Jugendstil» was initiated in Germany with the publication of the periodical «*Jugend*» in 1896, and in the same year the humoristic publication «*Simplizissimus*» was launched. Through and parallel with these publications a great number of young and up till then unknown artists came forward and devoted their gifts to the applied graphic arts.

At the turn of the century numerous books were published in Germany with covers conveying their spiritual character in a style corresponding with the contents in contemporary feeling and expression of art. Two publishers competed in the presentation of their new publications, Albert Langen of Munich, and S. Fischer of Berlin. They brought out the works of such provocative and contradictory Scandinavian writers as Knut Hamsun, Bjornson and Kierkegaard; the fashionable French novelists of the day, Maupassant and Zola; and the oncoming German writers, Hofmannsthal, Hauptmann, Wassermann, Schnitzler, Bahr and others of their circle. From the outset of this period, Otto Eckmann, with his decorative lettering, representative of the «Jugendstil» school, and Th. Th. Heine, the brilliant cartoonist, representative of the «Simplizissimus» group, were leading book-cover designers. The latter, with his irony and directness of imagination, and his excellent sense of colour, brought extreme animation to the outside appeal of the book, which had not been attained before. His colleague and great competitor, Olaf Gulbransson, entered the field; and among those representing the school of humour were Karl Arnold, Bruno Paul and Heinrich Zille. The latter designed his own jackets for his inimitable books giving such vivid pictorial accounts of the street life of Berlin.

Side by side with these humorous and pictorial jackets, a more decorative school came into being, following Otto Eckmann's inspiring initiative and lead, its ideas of lettering inspired by his brushwork, which in fact became a typefounder's type. Mention should also be made of Peter Behrens, who gradually gave up the graphic arts for architecture, and of Melchior Lechter, another member of this group, who was responsible for the controlled, almost pre-Raphaelite covers for the poetry volumes of Stefan George.

Some remarkable early German book-jackets carry the names of such distinguished artists as Emil Rudolf

Weiss, Walter Tiemann and F. H. Ehmcke. Their names became world-famous between the two wars, mainly as typographers and type designers, and indeed they were the educators of a whole generation of German designers.

The great painter Max Slevogt who, at the turn of the century, was for several decades the spiritual leader of the art life of Berlin, created but a few book-covers; but his work should be taken into account in the field of German book-cover designing at that time, attracting as it did lettering artists, humorists, calligraphers, painters, and even leading sculptors such as Max Klinger and Franz Stuck. Indeed it represented all those who were associated with German art and letters.

A small but typical cross-section of their work is reproduced on page XII. It is fortunate that these works are still preserved in Germany, in Mr. Kurt Tillman's unique private collection. In the 1940 volume of «*Imprimatur*» the Annual of the Society of German Bibliophiles, he published a lengthy history of the traditional German book-cover, adding to a remarkable range of illustrations some examples which fall within the interpretation of the book-cover as defined in this book.

In France, the yellow jacket with its bold black type faces was such a commonplace that no collector seems to have cared to preserve even the more interesting or outstanding creations. When Toulouse-Lautrec, Steinlen, Forain and others of their circle appeared on the stage in the last decades of the 19th century, their brilliance was well proved by their lithographic posters, and able publishers recognised that their work would be attractive and valuable on book-covers. In this form they were, of course, posters 'en miniature', and they are not only unique owing to their high artistic level, but because they are products of the artists' own hand on stone.

It is most fortunate for us that almost all of Toulouse-Lautrec's covers have been preserved in the famous collection of Mr. Ludwig Charell, the earliest dating from 1893 for a volume of *Reminiscences* of Aristide Bruant, the famous Cabaret artist, and the last dated 1901 for Paul Leclerc's «Jouets de Paris.»

But for their meteoric appearance and disappearance, there is very little to be said about the art of the French book-covers between 1890 and 1920. The lone attempts which can be looked upon as original were those of the French typographical school under the name of «Modern Style», inspired by the publisher Grasset, and the imaginative and remarkable Georges Auriol, whose typographical ideas are not to our taste today, but whose liveliness and technical achievement have not been, and hardly will be, bettered for a long time. He exercised an influence on the art of the book-cover of his day which penetrated less into the sphere of fiction publications, but left its mark on scholarly or scientific books, mainly on those published by L'Edition Larousse.

The Art of the Book-Jacket

Whether he be a book-buyer or not, anyone who passes a bookshop in any civilised country to-day will take it for granted that he will see displayed in the window an assorted colourful collection of books, each of them bearing a paper jacket carrying, in a bold or restrained fashion, title and author's name.

Some will be pictorial, challenging or modest, according to subject and treatment of the contents; others will strike the eye by reason of the subtle choice of lettering or the daring quality of abstract design; yet others will make their mark by virtue of their standardised form. But apart from the designers, producers and those who are connected with their actual sales, only a very few of the passing crowd, even if they be interested in books, will be aware of the amount of thought and careful planning that has gone to the creation of these covers.

For into a space that on the average is little more than six inches by eight inches it has been necessary to convey visually, by word or by design, the feeling and character of a book which often may run into four or five hundred pages. Those who succeed in achieving this aim by the skilful use of one of the many media open to them, be it pictorial or typographical, have every right to be called true artists; and it is not unreasonable by now to speak of the *art* of the book-jacket.

The good book-jacket is the product of an *editorial mind*, which is able to extract the essence of the whole contents of the book and project it on the cover in a visual manner. By its nature, Fiction is the most rewarding field for book-jacket design. The scientist looking for books within his own sphere of work, the architect searching for a technical handbook, the doctor or lawyer wishing to acquire professional publications — for such as these, the jacket does not have to *attract*. It is, of course, obvious that jackets for books of this type should impart the scholarly knowledge and competence of the contents, and the importance which the publisher attaches to their general production and presentation. From the optical point of view, these book-jackets only have to face competition from other books on the same or similar subjects. This also applies to books for leisure, such as angling, sailing, cricket and so on. The angler will select books on his hobby; so will the yachtsman or the cricket fan. As for jackets for Fiction, the competition is fierce, for they must attract and direct innumerable passersby who are undecided, looking for books for entertainment or escapist enjoyment: here the cover can tip the balance and draw the much-wanted interest.

There are limitless approaches within this category. As examples of jackets giving general atmosphere, no one can look at the covers of Dostoevsky's *The Demons*, (Chile, 20), *Thirst*, (Denmark, 39), *Dead Men Rising*, (Great Britain, 72), or *The Plague*, (USA, 195) without being seized by a feeling of dramatic events, even without a command of the language or a knowledge of the contents. In different ways, but with the same effect, the jacket can also convey the gist of a novel by sheer indication and implication, and without vulgarity (60 and 116).

But whatever the approach, jackets should adhere strictly to the basic rule of publicity: they should tell the truth. To present a book in a misleading jacket is like selling goods under false pretences, and in the long run it will do great disservice to publisher and author. Crime must be bluntly shown as such; fear appeals to many who enjoy this type of reading and its representation will attract the addicts. It is not by chance that American jackets at their best convey the contents of «thrillers» with the utmost clarity and attractiveness. According to George Salter, one of America's leading experts, there was no book-jacket designer in America before 1940, and if to-day there is a definite group of book-jacket designers in the States, they are certainly specialists. Examples of these presentations of crime and fear can be seen in 176 and 197, and their purposeful directness can hardly be equalled in any other country.

A portrayal of characters dominating the book, if aptly presented, can give a feeling of period and personality. What could give a clearer indication of contents — whether by original design or by application of period drawings — than the group presentation on the covers for *The End of the Notables* and *Vanity Fair*, both from Italy (107 and 113 respectively), or the portrait of individuals in USA, 175, Mr. Petit (Denmark, 40), or Pascual Duarte (Netherlands, 129)? Poland, 150, also falls in this group.

An equally plain and direct presentation of the feeling of the contents can be applied in more specialised spheres. The appeal of leisure and harmony of travel is obvious in the jacket for *A Notebook in Corsica* (73), and the impact of the dramatic tension of an African journey is immediate in 125. Readers looking for relaxation will be reassured by the cover for South America, 11, indicative of the predominant description of nature, and those interested in folklore will be guided by 166, *In the Swamps of Rio Nunez*, with the emblematic native mask.

The pictorial is not the only means of expressing the poetic or dramatic character of a book. An equally effective medium is written or drawn characteristic lettering. The jacket for Rilke's *Malte Laurids Brigge* (Sweden, 159), implies the poetic, biographical nature of the work, and this quality of statement is also obvious in the darkness and rigour of the jacket for a biography of Karl Marx (Switzerland, 169). National characteristics are apparent, for instance, in 47, expressive of the basic French response to negro spirituals, and the slightly more detached Nordic reaction to the same subject can be seen in Sweden, 160.

Jackets can indicate whether a subject is treated in a detached or more personal manner. *Oxford Replanned* (83) states that the case is presented by architects for architects; whereas *Norske Hus* (135) is less formal, handing the houses, as it were, to the would-be inhabitants.

Humour appeals without exception to children of all nations and creeds. It is an appeal which must also be felt by parents who wish to give pleasure to their children, and, with the aid of humour, competition has resulted in some of the most successful book-jackets of this type. This plane seems to dispense with national characteristics and barriers, and here the book-jacket has achieved its true internationalism — for example, the jackets for *The Fables of Aesop* (30), a nonsense tale by Edward Lear (32), both from Denmark, and *The Tell-Tale* (Poland, 152). Lebedev's covers for Russian children's books, which appeared in the 1930's, are classics of their kind (203-206), and the same vein can be detected in Roger Duvoisin's jacket for *Petunia* (USA, 202), with the charming duck.

But humour is not limited to book-jackets for the young. Could there be a more inviting cover than Osbert Lancaster's for a guide to Rome (Great Britain, 67), showing the ancient Roman's joyful welcome to the visitor? Almost Chaplinesque tragi-comedy is evident in 118, conveying life led in the Italian underground movement. An example of robust humour, typical of the farcical aspect of old France, is shown in 27, and the jacket for Ogden Nash's *Family Reunion* (180) will leave no one in doubt of the spirit of the book.

The book-jacket can express with equal directness and clarity both competence and standing. Cassandre's cover for a book on contemporary ballet (46), and George Giusti's for a volume on Modern Italian Art (USA, 200), stress the essentials, on an artistic level, and correspond with the authoritative character of the contents.

Abstract art, as a *tour de force* of mental concentration and a projection both of gist and spirit of a book, can establish the most immediate contact between intelligent book-buyers and intelligent writing. A near-classical achievement of this type comes from America (174).

* * *

To attain such achievements, the right artist must be chosen. He should be in sympathy with the contents of the book and possess the ability for visual communication. The publisher should define any specific editorial or technical requirements — whether emphasis should be given to the author's name, which is advantageous, for instance, on a book by personages of world prominence, such as Sir Winston Churchill or Marshal Stalin, or to the title, or whether equal emphasis should be given to both. If the publisher has firm views on the matter, he

should state if the presentation should be pictorial, typographical or calligraphical; whether the jacket should have a certain affinity with the basic characteristics of jackets of the author's previous volumes, or be a complete departure from them. It should be decided too whether the publisher's trademark is to appear on some part of the jacket, whether the artist can dispense with it if this helps him in his design, or whether it can be adapted according to the artist's style.

A decision should also be made on the reproduction methods, the kind and quality of material to be used and the number of colours. The publisher's wish on the controversial question of the direction of the lettering on the spine — whether it should run from bottom to top or from top to bottom, a question on which publishers are divided among themselves — should be clarified. It should be made clear to the artist at the outset if he is to be responsible for the typography of the blurb and for the remainder of the text on the jacket.

The creative impulse in book-jacket work is manifold. It can express itself just as well in type alone as in calligraphy, photography, drawing, engraving, painting, or indeed in their combinations, variations or permutations. The typographical jacket can express equally well the competence and dignity of a scholarly treatise, or, by the right choice of type and its animation, the more imaginative or more playful contents of a volume. By now, type-faces, which have been designed and cut in many countries for more than five centuries, are an inexhaustible source of riches for the typographer and designer conversant with their fundamental characteristics and the «know-how» of arrangement. How well can the gallantry, the moral structure, indeed the whole atmosphere of French life and letters be expressed through the admirable French type-faces of the eighteenth century; and how fittingly the factual information of industry and its problems can be conveyed through the mid-twentieth century San Serif and Egyptian.

Ornaments and borders, employed in a more conventional manner, can be put to imaginative use; and an appropriate choice of tinted paper, with even a single colour printing from type, can produce an eye-catching jacket.

Calligraphy, which has enjoyed a revival in the past decade, can furnish a welcome addition or solution, either combined with type or entirely on its own. To Edward Johnston's basic principle — to make good letters and arrange them well — the designer might remember Imre Reiner's practical comment that lettering, written or drawn, must be in full accordance with the character of the volume.

In dealing with type, ornaments and borders, the typographer-designer is arranging elements created by other artists. Calligraphy is the first step towards the work of his own hand. The feeling for letter-form is at its most sensitive in the calligrapher; for him it is not merely a matter for mass-production but one of acute personal interest and effort. This is reflected in his work and thus reaches the reader. Paul Standard has epitomised the calligrapher's aim by saying that the flow of one letter into the next makes for a unity and continuity that book-designers and publishers, as well as readers, are bound to favour; and, in the words of Rudolf Koch, the calligrapher is a servant, the poet or poetry his master. He has to give his text a beautiful, clear and sensible form. If this subordination to the text is an enforced one, as it were, from the outside, he is a craftsman; if it comes freely from his heart, he is an artist.

Calligraphy for reproduction purposes does not necessarily demand a thorough knowledge of reproduction techniques on the part of the artist. On entering the realm of imaginative drawing, though, it is necessary for him to have a command of process reproduction.

When the artist produces drawings or paintings for a book-jacket — and the creation of a suitable pictorial wrapper can give more opportunity for experiment than actual book-illustration — he must bear in mind first and foremost that the purpose of his work is to enable the printer to produce thousands of prints. The merit of his original — which is only seen by the publisher and printer — does not lie in the main in its beauty, but in its aptness for reproduction. Here the creator's technical knowledge must enable the printer in turn to create hundreds and thousands of jackets through multiplication, each faithfully conveying the directness and freshness of the original.

The artist's work can be reproduced by several methods, but the work of his own hand can only be directly multiplied by wood-engraving and autolithography. The former, when used on a jacket, is much more effective

if the artist engraves the lettering himself, but unfortunately there are far too few whose mastery of the engraving of lettering is equal to their ability in engraving in general.

Writing in *Signature*, No. 2, March, 1936, Barnett Freedman said that the immense range and strength of tonality that can be obtained, the clarity and precision of delicate and fine work, and the delightful ease of manipulation by the artist directly on to stone, plate or transfer paper, gives to autolithography a supreme advantage over other autographic methods. Daumier and his contemporaries discovered all there was to know about the black lithograph, but it is with colour that painters to-day will find autolithography most valuable. This activity is the nearest approach to actual painting, and the knowledge of colour that a good painter must necessarily acquire in his own studio can be used and, in fact, augmented by a close study of the colour lithograph.

Under no circumstances should artist or publisher be satisfied in assessing the merits of a design with the jacket spread flat on the drawing-board. The book-jacket is a three-dimensional product, and the optical appearance may prove to be quite different when even the front part is lifted by the body of the book. The sales promotion value of any jacket can be enhanced if it creates the optical illusion that the book is somewhat larger than it is. Books look smaller if a definite, shaped emblem with intense colours is surrounded by a frame or background of duller colour, while a more brilliant background than the colour or colours of the emblem will make the book appear larger. A pattern stretching from edge to edge with no interruption invariably gives an illusion of bigger size.

As the book-jacket is a three-dimensional product, in certain exceptional cases not only the front and spine, but the back of the jacket as well can be put to the use of pictorial presentation or decoration. This all-round jacket (see 74 and 111) is a great favourite with painters, who are accustomed to large surfaces. Such jackets can be turned to great advantage for display purposes too, as long as the text on the front is either repeated on the back or balanced with text of similar weight, then, when it is spread out flat for display it will not have an improvised appearance.

The approach to a problem may vary from artist to artist: the reproduction technique may vary according to its fitness of purpose and the economic factors. But if there is one item which can and should be looked upon as a standard ruling on each and every jacket, it is the impeccable legibility of the text. The way in which the essential message which a jacket transmits can and in many instances should be a piece of imaginative work, but the author's name and the title of the book are hard facts and should be presented in a factual manner.

It is just as well to remember that, in contrast with other commodities which have to compete with other articles, the book has to compete mainly with other books, either in a window or on a book-shelf. The making of a good book-jacket, therefore, largely depends on the fact whether the artist can create his own display background on the surface of the book, with image and text standing out in relief from the other books surrounding it.

The evolution of the book-jacket from its basic protective function into a piece of publicity has been fundamentally the same in all countries in which it is used.

In *Great Britain*, its development has taken place practically under our very eyes. Between the two world wars the most lasting influence on the English book-jacket in the field of typography and calligraphy was exerted by the Curwen Press, under Oliver Simon; by Victor Gollancz, under Stanley Morison; and by Jonathan Cape, with the cooperation of Hans Tisdall.

The innumerable varieties of typographical jackets, designed and produced by the Curwen Press, the wise choice of type-faces, combination of typographical borders and ornaments and the restrained use of colours, created an individual style. Oliver Simon has admirably defined the application of his typographical theories relating to the book-jacket in his clearly argued volume, *Introduction to Typography* (Faber & Faber, 1945). The average standard of these jackets over the past twenty years or so is exceedingly high, and they invariably appeal by reason of their good taste to people of good taste.

Stanley Morison, the greatest living authority on the history and art of typography, caused a surprise by creating hard-hitting and typographically the boldest jackets at so early a date as the 1930's. His yellow wrappers, with violet and black lettering, for the publishing house of Victor Gollancz, with whom he was associated at the time, made them recognisable at a glance. They were fully sucessful as examples of direct publicity at its best.

The distinctive jackets of the publishing house of Jonathan Cape, designed by Hans Tisdall, carry animated white lettering, with a sparing use of light blue and red against a standard black background. By now they too are classics of their kind.

As for the raising of the general standard of pictorial book-jackets from the point of view of the artist's own hand-work, the most lasting individual influence was exerted in the field of wood-engraving by John Farleigh, who was so intrigued by his experiences that in his book *Graven Image* (Macmillan, 1940), he included a valuable chapter on his aesthetical and technical appreciation of the book-jacket; by Barnett Freedman, who applied his creative and technical ability and sense of colour to the autolithographical jacket; and by Edward Bawden, whose simplification through the medium of lino-cut and flat colours added variety and originality.

Among the easel-painters, Duncan Grant, Graham Sutherland and John Piper have made the most lasting mark on the book-jacket; and among the younger generation in the past few years Kenneth Rowntree, John Minton and Keith Vaughan have made and are making permanent additions to the evolution of book-jackets, mainly in the creation of attractive visual presentations of the work of the more progressive writers.

It is interesting to note how little the straightforward publicity jacket appeals to the English character, and that, among publicity artists, not even one of the first rank has been able to establish himself in this sphere; nor are they commissioned by publishers, except for isolated experiments. On the other hand, the illustrator's work can often be applied to jackets by using reverse white out of the colour background, and some of the most delicate jackets of this kind, in the best possible taste, come from the hand of Lynton Lamb. There has not been what could be called a book-jacket design specialist in Great Britain, in the same way as there are quite a few such specialists in the United States. In the last two years or so, the only artist who seems to be concentrating on book-jackets more than on any other activity is B. Biro, who couples an able editorial brain with a graphic projection of the real essence of the book. From the point of view of visual expression, his jackets are clearly understandable to the wider public without sacrificing artistic taste.

It is hardly possible to give an over-all picture of *German* book-jackets in the inter-war years, as it was some time before publishing regained a more normal stride following the First World War.

In the years preceding 1933, however, the greatest influence exercised on German book-presentation was that of such eminent type-designers and lettering artists as Professor Rudolf Koch, F. H. Ehmcke, E. R. Weiss and Walter Tiemann. Their constant search for novelty and continual moving forward to new type-faces and their application left their mark on German book-jackets between 1924 and 1933. Side by side with this school, a more lighthearted type of book-jacket commanded wide appeal with animated illustrations in pastel colours and carefree lettering. Here the name of Hans Meid comes readily to mind.

Hitler's command that Gothic type-faces must be used in all books, and the suppression of free expression in word or image, more or less put a full stop to anything which could be called «art». Post-war German book-jackets up to about 1950 reflect the desire to eradicate from the artist's memory the dark periods through which Germany has recently passed, and this escapist attitude has in many instances led to German artists falling back on the gay, decorative designs of what was once their sunniest and happiest period, the Biedermeier, with its ornamental lettering, flower motifs and emblems, all printed in «sweet» colours on frequently fanciful papers. Since then, several artists who have been devoting their ability to the book-jacket in Western Germany are standing on firmer ground, and, as in many other spheres of the German graphic arts, a rebirth is taking place.

Realism comes from Germany's two neighbours: *Switzerland* and *Czechoslovakia*. After 1933, free thought freely expressed by Germans in their own tongue found refuge, if it was to be printed in the German language, in Switzerland. This brought an unexpected boom to Swiss publishing. Publishers gave opportunity to printers and artists to present their books both inside and outside up to the best Swiss level. It is more an underlying sense of responsibility, both in the creative work and its execution, than any single achievement which stands out in Swiss book-jackets. There is a strong sense of colour and of making the best of as few of them as possible. The deep-rooted tradition of the teaching of humanism at Basle is displayed, coupled with the fine technical ability for reproduction in Zurich and the North-East of Switzerland. The Swiss jackets reflect a high degree both of civilisation and of craftsmanship.

Out of the general high level of Swiss design, for which their most accomplished artists are responsible, the three main trends can be best observed in the work of Richard Lohse, the contemporary designer, Robert Sessler, the graphic artist *par excellence*, and Pierre Gauchat, the painter.

The intensely strong, centuries-old feeling about the Austrian domination of their country, led the first Government of the Czechoslovak Republic in 1918, in one of their initial decrees, to establish the Czech and Slovak language as the official tongue. This meant a great boom in book-publishing, which was fortunate in being able to fall back upon an already efficient printing industry. Due to Method Kalab's typographical knowledge and unusual ability to make artists fall in with his ideas of typography and general design, an entirely new school of Czechoslovak book illustrators and book-jacket designers came into being. What had been comparatively timid covers were gradually replaced by those of a more forceful character, and in turn reflected the influence of Expressionism and Cubism, leading in many instances to the use of Surrealist symbolism. A fearless use of the strongest colours or combination of colours was and is a constant characteristic, disregarding any current trends in art that may be prevalent.

Two signatures stood out on the most striking *Hungarian* jackets between 1930 and 1940: that of Georges Rado — now a successful commercial artist in Brazil — appeared on the more graphic onces, while that of Alexsander Fenyves was conspicuous on the more pictorial ones. Both had an excellent sense of colour which they combined with clarity and animation of lettering. One of the names appearing most frequently on the few specimens to reach the West to-day is that of Vera Csillag, who is carrying on the good work begun and established by the other two artists.

A leading London publisher has said that his firm spends a considerable amount of money on lavish book-jackets, printed in several colours, even for those books which are sold — if not entirely, then in the main — to lending libraries, institutions who order copies without jackets. The wrappers are produced for the sole

purpose of impressing upon his sales staff the importance of any given book and his trust in it as a publisher.

This is, of course, quite understandable in countries where hundreds of publishing houses compete with each other for the favour of the public, but in countries where all the publishing firms are taken under the wing of the State and put, as it were, into its pocket, a cessation of such extravagant expenditure would seem to be probable. It is, therefore, most remarkable to note the variety and artistic quality of the books which have been issued up to the present under various imprints by one and the same State publishing house in *Poland*. It has its own creative studio for the purpose of presentation of its books and employs artists of the rank of Tomaszewski, Rychlicki, Bernacinski and Cherka among the older generation, and Jen Lenica and Baro among the younger.

In countries where books are not clothbound, but are generally put on the market in limp paper covers, as, for instance, in Sweden and France, the cover is an integral part of the book and cannot be removed in the same way as a loose jacket. Accordingly the cover goes into a library with the book, and this consideration limits the use of strongly colourful or «noisy» jackets with a leaning towards publicity.

A skilful book-jacket designer, Akke Kumlien — the greatest Scandinavian artist in lettering — has for the past thirty years left his mark on *Swedish* book-jackets. They were restrained, both in design and colour, and displayed dignity and distinction, mainly as a result of his calligraphy. In the last few years, however, the trend of Swedish publishing has turned more to the English style of book-production, and while part of an edition has been marketed in paper covers, part has been cloth-bound with a loose jacket. This has broadened the traditional approach to the book-cover, so that now, although the old traditional one continues, we find a new approach being made, with Olle Eksell, a designer with a vivid imagination, representing the new school. During his stay in the United States, he was influenced by certain front-ranking American designers, and after his return to Sweden his earlier jackets showed this trend. Since his more recent association, however, with Bonniers, the leading Swedish publishers — where Iwan W. Fischerstrom has for many years established a high standard of competence in traditional book-covers — Eksell has been able to absorb his experiences in the States. His work has become more personal, and the ultimate result is to be seen at its best mainly in his Folk-Lexicon jackets.

In *France*, it was not until the mid-thirties of this century that general publishers became interested in the outside presentation of their publications. Books, in general, had a yellow or green paper cover with black letterpress printing, and for the latter any type which the printer happened to have at hand was used without the least thought being given to typographical care or general appeal. Under the spiritual influence of Charles Peignot, who made printers and designers more type-conscious than the French have been since the mid-nineteenth century, increasing interest has been taken in book-covers as well. Bernard Grasset, using different coloured papers of far superior quality to the familiar yellow one, and careful, and frequently witty, typographical variations and unorthodox combinations of type-faces to embellish his covers, stands out as the first of the French publishers who gave thought and care to the covers of his books. While Maximilien Vox — the ever-inspired designer of books — has been mostly instrumental in the revival of the outside «presentation» of the French book.

In addition to his activities as a writer, Jean Cocteau directs his own plays and films. As a graphic artist he shows the association between the decadence of Ancient Greece and the France of to-day, and the book-jackets for his volumes in the series, *Le Livre de Demain*, are embellished by his own drawings and lettering.

More and more — but still too few — French book-jackets carry Jean Denis Malclès' strongly personal decorative designs; while Jean Colin's appealing covers are appearing on a series of reprints. For the first time, the major works of the great writers of the first quarter of this century — which are already becoming classics — are offered at a very reasonable price. These covers have solved the problem of the presentation of great literature through intelligent publicity in good taste, for jackets more typical of the actual style of the books would hardly appeal to the wider public.

Although they lie between Sweden and France, Denmark and Holland were actually influenced more by English and German schools of book-production.

Denmark — a small country with the greatest percentage of readers per population among the European nations — is of an independent mind. The number of new titles — original works and translations of foreign

writing — is astounding, and so are the comparatively low book prices. The Danes' sense of humour — so prevalent in their numerous newspaper cartoons — has a strong bearing on their book-jackets. Thus the work of such remarkable artists as Arne Ungerman, Paul Hoyrup and Des Asmussen, whose strength lies in this interplay of the sense of the comic, carries the day.

Holland, with its great printing tradition, has long reverenced the outside of the book just as much as the inside. A distinguished type-designer, Jan van Krimpen, appeared on the scene in the inter-war years, his ability as a calligrapher equalling his knowledge as a typographer. His animating influence, coupled with a considerable import of German and English books, and their competitive appeal on the book-counter, made Holland move forward. In the early post-war years, Helmut Salden's lettering opened new vistas, for while preserving the best tradition of exactitude and clear-cut legibility, he added originality and liveliness.

As for unorthodoxy in typography and a vigorous modern approach, W. Sandberg's name is no doubt the most eminent in Holland to-day, while the unfortunately too few jackets of Dick Elffers show only a part of the full strength of this foremost Dutch graphic artist.

The work of Bertram A. Th. Weihs for book-jackets has the boldness and pleasurable spontaneity reminiscent of the characteristics of the Southern States of America.

The verve of Italian post-war films and the economical manner in which they are produced characterises the *Italian* book-jackets as well. Leading publishers such as Mondadori, Einaudi and Longanesi show a great preference for publishing their books in series; each title, however, carries an individual jacket which through its basic characteristics makes it evident that the book belongs to a series, while displaying the individual volume at its best. The typography is clear and both choice of type-faces and the way in which various type-faces are combined on the same jackets makes them the most purposeful of any Latin country.

As for the *U S A*, as far back as 1930 Henry F. Pitz, in his volume on *American Book Illustration*, said: «A collection of contemporary book-jackets serves as a barometer of interest and taste. One can easily imagine a scholar of a hundred years hence poring over them with fascination. They will carry the flavour of our age as effectively as the Victorian valentines or the early English chapbooks do theirs.»

In selecting the material for the International Book-Jacket Exhibition at the Victoria and Albert Museum, however, it was distressing to find that with a few exceptions in the USA almost all popular fiction jackets fell without question into the rejected class, and those finally selected were limited almost exclusively to covers on belles-lettres, poetry, books on fine arts and a few academic titles. This meant in other words that ninety per cent of the selected jackets would never have been seen or noticed by the average American low-brow novel-reader.

In no other single country, therefore, is it possible to make such a clear division between the *presentation* and *publicity* jacket as it is in the United States. An unequalled sense and knowledge of calligraphy and animated lettering in general is characteristic of the first — here George Salter is outstanding — and an unlimited use of imagination characteristic of the second, with Alvin Lustig predominant in the field of abstract presentation. The American decorative jacket at its contemporary best finds its most distinguished representative in Joseph Low.

The printing and general finish of American jackets are far superior to those of any other country, and it is only fair to say that the American has solved the problem of making the book-jacket an attractive piece of publicity and an ideal dust-wrapper.

The fact that a group of artists formed a Book-Jacket Designer's Guild in New York in 1947, which stages an annual exhibition for the purpose of promoting and stimulating interest in the art of book-jacket design, is welcome. It can only be hoped that they will succeed in their intention to elevate the artistic level of the American book-jacket by means of «system panel discussions and mutual encouragement». The Guild has already succeeded in arranging an exhibition entitled *The History of the Book-Jacket* for the American Institute of Graphic Art (1950), and only just over twenty years since Henry F. Pitz's comment on the value of a collection of contemporary book-jackets, a permanent one is housed in the Metropolitan Museum of Art, New York, which is currently amplified by the Guild.

Index

	DESIGNER	AUTHOR	ORIGINAL TITLE	TRANSLATION	CATEGORY	PUBLISHER
1	Gori Munoz	Moreau de Jonnes	Los Tiempos Mitologicos	Age of Mythology	Non-fiction	Editorial Schapire
2	Attilio Rossi	Adolfo Salazar	La Musica Moderna	Modern Music	Art	Editorial Losada
3	Horacio Butler	George B. Cressey	Tierras y Pueblos de Asia	Lands and People of Asia	Topography	Editorial Sudamericana, Buenos Aires
4	Gori Munoz	Camilo Mauclair	Historia de la Musica Moderna	A History of Modern Music	Art	Editorial Schapire
5	Horacio Butler	Eve Curie	Viaje Entre Guerreros	Journey between two Wars	Non-fiction	Editorial Sudamericana, Buenos Aires
6	Douglas Annand		Australia Weekend Book No. 5		Anthology	Ure Smith, Sydney
7	Douglas Annand	A. P. Elkin & R. & C. Berndt	Art in Arnhem Land		Art	Cheshire
8	Douglas Annand	Marjorie Barnard	Macquarie's World		Fiction	Melbourne University Press, Melbourne
9	Douglas Annand	Amery Paul	It Could Be So		Children's Book	
10	Douglas Annand	Rohan Rivett	Behind Bamboo		Fiction	Angus and Robertson, Sydney
11	Kurt Schwarz	Victor Wolfgang von Hagen	Südamerika ruft	South America Calls	Travel	Büchergilde Gutenberg, Wien
12		Doderer	Ein Umweg	The Detour	Fiction	Gebr. Rosenbaum, Wien
13	Kurt Schwarz	Braungraber	Zucker aus Cuba	Sugar from Cuba	Fiction	Büchergilde Gutenberg, Wien
14	Clair Stewart	Robertson Davies	The Diary of Samuel Marchbanks		Non-fiction	Clarke, Irwin & Co.
15	Eric Aldwinckle	Morley Callaghan	The Varsity Story		Fiction	Macmillan Company, Toronto
16	Mauricio Amster	Karel Capek	La Guerra con las Salamandras	War with the Newts	Fiction	Empresa Editora Zig-Zag, Santiago de Chile
17	G. Delano Carrasco	A. Blest Gana	La Fascinacion	Fascination	Fiction	Empresa Editora Zig-Zag, Santiago de Chile
18	Mauricio Amster	Jose Maria Souviron	La Luz No Esta Lejos	The Light is not Far	Fiction	Empresa Editora Zig-Zag, Santiago de Chile
19	Mauricio Amster	Gustav Meyrink	El Rostro Verde	The Green Mask	Fiction	Empresa Editora Zig-Zag, Santiago de Chile
20	Mauricio Amster	Fedor Dostojewski	Los Endemoniados	The Demons	Fiction	Empresa Editora Zig-Zag, Santiago de Chile
21	F. B.	Frana Sramek	Bourky a Duhy	Gods and Phantoms		
22	Jaroslav Svab	Luc Dietrich	Stesti zarmoucenych	The Joy of the Distressed	Fiction	Vaclav Petr, Praha
23	Josef Prazak	Jiri Skorepa	Orfeus	Orpheus		Nakladatelske Druzstvo Maje
24		Jarmila Glazarova	Chuda Pradlena	The Poor Washerwoman	Fiction	Druzstevni prace, Praha
25	Karel Svolinsky	Geoffrey Chaucer	Canterburske Povidky	Canterbury Tales	Poetry	Druzstevni prace, Praha
26	Josef Prchal	Emanuel Roblès	Stavka	Strike	Fiction	Nakladatelske Druzstvo Maje
27	Antonin Strnadel	Pavel Eisner	Smich Stare Francie	The Laughter of Old France	Anthology	Druzstevni prace, Praha
28	Joseph Hochman	Rex Warner	Letiste	The Aerodrome	Fiction	Prace, Praha
29	Karel Teissig	Rex Warner	Marna Honba	The Wild Goose Chase	Fiction	Prace, Praha
30	Mogens Zieler	R. Broby-Johansen	Den Lille Aesop	The Little Aesop	Children's Book	Gyldendal, Copenhagen
31	Mads Stage	H. D. Thoreau	Livet i Skovene	Life in the Woods	Fiction	Kunst og Kultur, Copenhagen
32	Arne Ungermann	Edward Lear	Historien om fire born en missekat og en kvanki-vanki	Tales of four children, a kitten and the pot kvanki-vanki	Children's Book	Gyldendal, Copenhagen
33	Des Asmussen	P. G. Wodehouse	Hurtig Ekspedition	Hasty Journey	Fiction	Jespersen og Pio, Copenhagen
34	Arne Ungermann	Mogens Linck	Paa Vej	On Your Way	Fiction	Gyldendal, Copenhagen
35	Helge Refn	Kjeld Abell	Miss Plinckby's Kabale	Miss Plinkby's Intrigue	Play	Thaning & Appel, Copenhagen

DESIGNER	AUTHOR	ORIGINAL TITLE	TRANSLATION	CATEGORY	PUBLISHER
36 Frede Christoffersen	Gabriel Chevallier	Drengeskolen Sainte-Colline	Sainte Colline	Fiction	Carit Andersen, Copenhagen
37 Paul Hojrup	Emile Zola	Menneskedyret	The Human Animal	Fiction	
38 A. Sikker Hansen	Piet Hein	Vers af denne verden	Poems of this World	Poetry	Gyldendal, Copenhagen
39 Ib Anderson	Birgit Tengroth	Torst	Thirst	Fiction	Hasselbalch
40 Helge Refn	Alice Guldbrandsen	Hr. Petit	Mr. Petit	Fiction	Gyldendal, Copenhagen
41 Werner Söderström	A. W. Rancken & Kauko Pirinen	Suomen Vaakunat ja Kaupunginsinetit	Finnish Shields and Seals	Art	Werner Söderström Osakeyhtiö
42 Werner Söderström	Einari Vuorela	Runoja	Poems	Poetry	Werner Söderström Osakeyhtiö
43 Werner Söderström	Osmo Hormia	Matka-Laulu	A Journey and a Song	Fiction	Werner Söderström Osakeyhtiö
44 Werner Söderström	Kansallinen Aarre	Kalevala	Kallevala	Epic	Werner Söderström Osakeyhtiö
45 Jean Cocteau	Jean Cocteau	Les enfants terribles	The terrible Children	Fiction	Librairie Arthème Fayard, Paris
46 A. M. Cassandre	Pierre Michaut	Le Ballet Contemporain	Contemporary Ballet	Art	Plon, Paris
47 J. M. L. Richard	Blaise Cendrars	Anthologie Nègre	Negro Songs	Anthology	
48 Abel		Le Miracle de la Veillée	The Miracle of the Vigil	Non-fiction	Editions du Seuil, Paris
49 Jacques Demachy	Betty Smith	Le Lys de Brooklyn	A Tree Grows in Brooklyn	Fiction	Hachette, Paris
50 Rémy Peignot	Paul Marteau	Le Tarot de Marseille	The Playing Cards of Marseilles	Art	Arts et Métiers Graphiques, Paris
51 Frederic	J.-H. Bernecque	Le Livre des Mères	The Mother's Book	Art	Arts et Métiers Graphiques Paris
52 Wilhelm Neufeld	Joseph von Eichendorff	Aus dem Leben eines Taugenichts	From the Life of a Good-for-Nothing	Fiction	
53 E. R. Vogenauer	Hartmut Bastian	Das geologische Abenteuer	The Geological Adventure	Non-fiction	Minerva-Verlag, Berlin
54 John Heartfield	Larissa Reissner	Oktober	October	Non-fiction	Malik-Verlag, Berlin
55 H. Kiessling	Curt Hotzel	Der Eselskopf	Ass's Head	Fiction	Dom-Verlag
56 Hans Hermann Hagedorn	Herman Melville	Moby-Dick	Moby-Dick	Fiction	Claassen-Verlag, Hamburg
57 F. H. Wills	Heinrich von Kleist	Über das Marionetten-theater	The Marionette Theatre	Art	Steuben-Verlag, Berlin
58 Kurt Tillesen	Henry Williamson	Die schönen Jahre	The Beautiful Years	Fiction	S. Fischer-Verlag, Frankfurt
59 Martin Kausche	Klaus Mann	Der Wendepunkt	The Turning Point	Autobiography	S. Fischer-Verlag, Frankfurt
60 Martin Andersch	Ivar Lo-Johansson	Monna	Monna	Fiction	Ernst Tessloff Verlag, Hamburg
61 Karl Staudinger	Bertolt Brecht	Der Dreigroschenroman	The Beggar's Opera	Fiction	Verlag Kurt Desch, München
62 Hans Peter Hort	Joseph Velter	Überfall auf die Goldwasserfarm	Attack on a Farm	Children's Book	Volker-Verlag, Köln
63 Gerhard C. Schulz	Howard Spring	Geliebte Söhne	My son, my son	Fiction	Claassen-Verlag, Hamburg
64 R. P. Litzenburger	Bartolini	Fahrraddiebe	Bicycle Thieves	Fiction	Stahlberg-Verlag, Karlsruhe
65 Johannes Boehland	Kurt Ihlenfeld	Wintergewitter	Winter Storm	Fiction	Eckart-Verlag, Witten
66 Helmut Lortz	Robert Nathan	Die Frau des Bischofs	The Bishop's Wife	Fiction	Rowohlt-Verlag, Hamburg
67 Osbert Lancaster	Osbert Lancaster	Facades and Faces		Travel	John Murray, London
68 Keith Vaughan	Raymond Queneau	A Hard Winter		Fiction	John Lehmann, London
69 Keith Vaughan	Arthur Rimbaud	A Season in Hell		Poetry	John Lehmann, London
70 Hans Tisdall	Michael McLaverty	The Game Cock		Fiction	Jonathan Cape, London
71 Barbara Jones	Barbara Jones	The Unsophisticated Arts		Art	Architectural Press, London
72 Aleksander Werner	Seaforth Mackenzie	Dead Men Rising		Fiction	Jonathan Cape, London
73 John Minton	Alan Ross & John Minton	Time Was Away		Travel	John Lehmann, London
74 John Farleigh	John Farleigh	Graven Image		Art	Macmillan & Co., London
75 John Piper	Palinurus	The Unquiet Grave		Autobiography	Hamish Hamilton, London
76 Lynton Lamb	Lydia Avilov	Chekhov in my Life		Autobiography	John Lehmann, London
77 John Piper	Henry Cecil	Full Circle		Fiction	Chapman & Hall, London
78 Biro	Barnaby Conrad	Death of a Matador		Fiction	Michael Joseph, London
79 John Piper	Norman Hancock	An Innocent Grows Up		Autobiography	J. M. Dent, London
80 Keith Vaughan	David Gascoyne	A Vagrant		Poetry	John Lehmann, London
81 Michael Ayrton	Frederic Wakeman	The Wastrel		Fiction	Allan Wingate, London
82 Edward Bawden	Ambrose Heath	Good Food Without Meat		Cookery-book	Faber & Faber, London
83 Gordon Cullen	Thomas Sharp	Oxford Replanned		Art	Architectural Press, London
84 Clifford & Rosemary Ellis	Ernest Neal	The Badger		Non-fiction	Collins, London

DESIGNER	AUTHOR	ORIGINAL TITLE	TRANSLATION	CATEGORY	PUBLISHER
85 Robert Turner	Philip Owens	Bed and Sometimes Breakfast		Anthology	Sylvan Press, London
86 Cecil Keeling	Jack Lindsay	Catullus, the complete poems		Poetry	Sylvan Press, London
87 Reynolds Stone	Mona Wilson (Ed.)	Dr. Johnson		Anthology	Hart Davis, London
88 Asgeir Scott	René Béhaine	Day of Glory		Fiction	Allen & Unwin, London
89 Lucian Freud	Nicholas Moore	The Glass Tower		Poetry	Poetry London
90 W. Stobbs	Kathleen Nott	Landscapes and Departures		Poetry	Poetry London
91 Edward Bawden	Eric Linklater	Mr. Byculla		Fiction	Hart Davis, London
92 Felix Kelly	Una Pope Hennessy	Charles Dickens		Biography	Chatto & Windus, London
93 Lynton Lamb	Christina Hole	Haunted England		History	B. T. Batsford, London
94 Barnett Freedman	John Hersey	The Wall		Fiction	Hamish Hamilton, London
95 Hans Tisdall		Ideas and Beliefs of the Victorians		Anthology	Sylvan Press, London
96 Michael Middleton	Edward Sackville-West	And So To Bed		Anthology	Phoenix House, London
97 Ronald Searle	Angus Wilson	Hemlock and After		Fiction	Secker and Warburg, London
98 Vera Csillag	Dostojewskij	Bün és Bünhödés	Crime and Punishment	Fiction	Franklin-Tarsulat, Budapest
99 Sándor Fenyves	Marai Sandor	A szegények iskolaja	The School Of The Poor	Non-fiction	Révai, Budapest
100 Sándor Kolozsvary		A Szerelem Kalandjai	The Adventures of Love	Anthology	Franklin-Tarsulat, Budapest
101 Sándor Kolozsvary	Alexander Puschkin	Anyégin	Eugene Onegin	Poetry	Franklin-Tarsulat, Budapest
102 Satyajit Ray			Bengali Poems	Poetry	Signet Press, Calcutta
103 Satyajit Ray			Lili Madymadar		Signet Press, Calcutta
104 Hind Kitabs	Humayun Kabir	Men and Rivers		Fiction	Hind Kitabs, Bombay
105 Satyajit Ray			The Thoughtless Youth		Signet Press, Calcutta
106 Nachum Gutmann	D. Schimonowitz		The Book of Idylls		Massadah
107 Leo Longanesi	Daniel Halévy	La Fine dei Notabili	The End of the Notables	History	Longanesi & C.
108 Leo Longanesi	E. B. Ford	Genetica	On Genetics	Non-fiction	Longanesi & C.
109 Einaudi	Jean Rostand	Piccola storia della biologia	The Short History of Biology	Non-fiction	Giulio Einaudi
110 Leo Longanesi	Gerhard Boldt	Ero con Hitler	I was with Hitler	Non-fiction	Longanesi & C.
111 Angoletta	Tschechow	Cechov	Tales of Chechov	Fiction	Aldo Garzanti
112 Leo Longanesi	Aubrey Menen	Il Domino delle Streghe	The Rule of the Witches	Fiction	Longanesi & C.
113 L. Crippa	Thackeray	La Fiera della Vanità	Vanity Fair	Fiction	Istituto Editoriale Italiano, Milano
114 Muggiani	Otto Ludwig	Fra Cielo e Terra	From the Sky to the Earth	Fiction	Guiseppe Muggiani, Milano
115 Leo Longanesi	I. F. Powys	Il buon vino del Signor Weston	Mr. Weston's Good Wine	Fiction	Longanesi & C.
116 Leo Longanesi	W. R. Burnett	Piccolo Cesare	Little Caesar	Fiction	Longanesi & C.
117 Salvador Dali	William Shakespeare	As you like it		Fiction	Visconti
118 Rizzoli	Guareschi	Diario Clandestino	Underground Diary	Autobiography	Rizzoli
119 Yusaku Kamekura			Annual of Photography	Art	Arts Publishing Company
120 Yusaku Kamekura			Ancient Japanese Arts	Art	Arts Publishing Company
121 Yusaku Kamekura			Ancient Japanese Wood Carving	Art	Arts Publishing Company
122 Hiroshi Ohchi			Manual of Mathematics	Science	Aoba Shobo
123 Bertram A. Th. Weihs	Jan Wever	Journal	Diary	Travel	A. A. M. Stols, 's-Gravenhage
124 Jan van Krimpen	Dr. Jane de Iongh	Maria van Hongarije	Mary of Hungary	History	Em. Querido, Amsterdam
125 C. J. Kelfkens	Graham Greene	Reis zonder kaarten	Journey without Maps	Travel	Contact, Amsterdam
126 Dick Elffers	Ir. S. H. Stoffel	De Massa-Mensch en zijn toekomst	The Mass-Man and his Future	Non-fiction	Uitgeverij vrij Nederland, Amsterdam
127 Wim Brusse	Paul Bromberg	Alarm — een verhaal voor de jeugd	Alarm — a Story for Youth	Fiction	De Bezige Bij, Amsterdam
128 Henk Krijger	D. Opsomer	De angst bedankt	The Fear Declines With Thanks	Fiction	Boucher, 's-Gravenhage
129 Bertram A. Th. Weihs	Camilo José Cela	De Familie van Pascual Duarte	The Family of Pascual Duarte	Fiction	Allert de Lange, Amsterdam
130 Jan Goeting	Marnix Gijsen	Joachim van Babylon	Joachim van Babylon	Non-fiction	A. A. M. Stols, 's-Gravenhage
131	P. M. S. Blackett	Atoomenergie en zijn gevolgen	Atomic Energy and its Consequences	Non-fiction	Wereldbibliothek, Amsterdam
132 Otto Treumann	Anaïs Nin	Djuna's droomzegel	Djuna's Dreamship	Fiction	De Driehoek, s'Graveland
133 Thorbjorn Egner	Hans E. Kinck	Hvitsymre i Utslaatten	Anemones in the Distance	Fiction	H. Aschehoug & Co., Oslo
134 Fredrik Frantze	Armstrong Sperry	Mafatu	Mafatu	Travel	J. W. Eides Forlag, Bergen

	DESIGNER	AUTHOR	ORIGINAL TITLE	TRANSLATION	CATEGORY	PUBLISHER
135	Frithjof Tiedemand-Johannessen		Norske Hus	The Norwegian House	Art	H. Aschehoug & Co., Oslo
136	Jerzy Karolak	Lucyna Krzemieniecka	Pan Klet i jego klejnoty	Mr. Klet and his Jewels	Fairytale	Czytelnik, Warsaw
137	Henryk Tomaszewski	Alicja Dryszkiewicz	Wedrowki po zwierzyncu	Travels in the Zoo	Children's book	Ksiazka i Wiedza, Warsaw
138	Henryk Tomaszewski	Stanistaw Jerzy Lec	Zycie jest Fraszka	Life is a Jest	Children's book	Ksiazka i Wiedza, Warsaw
139	Jerzy Karolak	Aniela Gruszecka	W Grodzie Zakow	In the Town of Olden Days	Children's book	Czytelnik, Warsaw
140	Zbigniew Rychlicki	L. Pantelejew & J. Sotnik	Stowo Honoru	My Word of Honour	Children's book	Ksiazka i Wiedza, Warsaw
141	Zbigniew Rychlicki	Upton Sinclair	Czlowiek który szuka prawdy	The Common Day	Fiction	Ksiazka i Wiedza, Warsaw
142	Henryk Tomaszewski	Martin Andersen-Nexö	Ditta	Ditta	Fiction	Ksiazka i Wiedza, Warsaw
143	Eryk Lipinski	Pola Gojawiczynska	Powszedni Dzien	The Seeker for Truth	Fiction	Ksiazka i Wiedza, Warsaw
144	Zbigniew Rychlicki	E. Panfierow	Bruski	Bruski	Fiction	Ksiazka i Wiedza, Warsaw
145	Zbigniew Rychlicki	Sinclair Lewis	Babbit	Babbit	Fiction	Ksiazka i Wiedza, Warsaw
146	Baro	Charles Dickens	Ciezkie Czasy	Hard Times	Fiction	
147	Ha-Ga & Eryk Lipinski		Opowiedzial Dzieciol Sowie	What the Woodpecker told the Owl	Children's book	Czytelnik, Warsaw
148	Jan Lenica	Rose Wuhl	Czapka madrosci	The Cap of Wisdom	Fiction	Czytelnik, Warsaw
149	Zbigniew Rychlicki	Martin Andersen-Nexö	Czerwony Morten		Fiction	Ksiazka i Wiedza, Warzaw
150	Ignacy Witz	Traven	W jarzmie	Under the Yoke	Fiction	Ksiazka i Wiedza, Warzaw
151	Zbigniew Rychlicki	Wiera Panowa	Kruzylicha		Fiction	Ksiazka i Wiedza, Warzaw
152	Olga Siemaszko	Jan Brzechwa	Skarzypyta	The Tell-Tale	Children's book	Czytelnik, Warsaw
153	Manuel de Pavia Ribeiro	Antunes da Silva	Vila Adormecida	The Life of Jesus Christ	Biography	Portugalia Editores, Lisbon
154	R. Giralt Miracle	Guiseppe Ricciotti	Vida de Jesu Cristo	Sleepy Village	Fiction	Luis Miracle, Barcelona
155	R. Giralt Miracle	H. W. van Loon	Las Artes	The Arts of Mankind	Art	Luis Miracle, Barcelona
156	Olle Eksell	Lars Ahlin	Egen Spis	Your Own Stove	Anthology	Kooperativa Fürbundets Bokförlag, Stockholm
157	Olle Eksell		Hardkokt	Hard-boiled	Crime novel	Kooperativa Förbundets Bokförlag, Stockholm
158	Olle Eksell	Denys Val Baker	Författare av i dag	Authors of Today	Anthology	Kooperativa Förbundets Bokförlag, Stockholm
159	Iwan Fischerstrom	Rainer Maria Rilke	Malte Laurids Brigge	The Notebooks of Malte Laurids Brigge	Biography	Ljus Förlag, Stockholm
160	Birger Lundquist	Thorsten Jonsson	Mörk Sang	Dark Song	Anthology	Albert Bonnier Förlag, Stockh.
161	Robert Sessler	Josef Reinhart	Der Galmisbub	The Shepherd Boy	Fiction	H. R. Sauerländer & Co., Aarau
162		Jakob Bührer	Im roten Feld	In the Red Field		Büchergilde Gutenberg, Zürich
163		Josephine Pinckney	Das Hochzeitsdiner	The Wedding Dinner	Fiction	Büchergilde Gutenberg, Zürich
164	Hans Erni	Hans Erni	Elemente zu einer künftigen Malerei	Elements of Future Painting	Art	Zollikofer, St. Gallen
165	Felix Hoffmann	Kurt Held	Der Trommler von Faido	The Drummer from Faido	Fiction	H. R. Sauerländer & Co., Aarau
166		Bowald	In den Sümpfen des Rio Nunez	In the Swamps of Rio Nunez	Travel	Büchergilde Gutenberg, Zürich
167	Hans Falk	Richard Weiss	Volkskunde der Schweiz	Swiss Folklore	Topography	Eugen Rentsch, Zürich
168	Leo Leuppi	Hans Arp	Onze Peintres vus par Arp	Eleven Painters	Art	Girsberger, Zürich
169	Richard P. Lohse	Franz Mehring	Karl Marx	Karl Marx	Biography	Büchergilde Gutenberg, Zürich
170	Alfred Willimann	Paola Drigo	Maria Zef	Maria Zef	Fiction	Verlag Huber & Co., Frauenfeld
171	Pierre Gauchat	Lou Andreas-Salomé	Lebensrückblick	Review of Life	Biography	Max Niehans Verlag, Zürich
172	Walter Herdeg	H. G. Wells	Der Geist am Ende seiner Möglichkeiten	Mind at the End of its Tether	Non-fiction	Amstutz & Herdeg, Zürich
173		Harry Harvest	Maßloses Rußland	Immense Russia	Non-fiction	Rotapfel-Verlag, Erlenbach
174	Alvin Lustig	Tennessee Williams	Summer and Smoke		Fiction	New Directions, New York
175	Alvin Lustig	Stendhal	The Telegraph		Fiction	New Directions, New York
176	Irving Miller	Helen McCloy	Through a Glass, Darkly		Fiction	Random House, New York
177	David Stone Martin	Francois Boyer	The Secret Game		Fiction	Harcourt, Brace & Co., New York
178	H. Lawrence Hoffman	Thurmann Warriner	Method on his Murder		Fiction	Macmillan Company, New York
179	S. K. A. Associates	William Demby	Beetlecreek		Fiction	Rinehart & Co., New York
180	Barbara Corrigan	Ogden Nash	Family Reunion		Satiric Poetry	Little, Brown & Co., Boston
181	Peter Hollander	Daniel Lerner	Sykewar		Non-fiction	George W. Stewart, New York
182	William G. Meek	John A. Kouwenhoven	Made in America		Art	Doubleday & Co., Garden City, N. Y.
183	Joseph Karov	Edward Lasker	Chess and Checkers		Non-fiction	Halcyon House, New York
184	Salvador Dali	Maurice Sandoz	On the Verge		Fiction	Doubleday & Co., Garden City, N. Y.

	DESIGNER	AUTHOR	ORIGINAL TITLE	TRANSLATION	CATEGORY	PUBLISHER
185	Paul Rand	Paul Rand	Thoughts on Design		Art	Wittenborn & Co., New York
186	John Begg	S. Giedion	Mechanization Takes Command		Science	Oxford University Press, New York
187	Paul Rand	Lucius Beebe	The Stork Club Bar Book		Anthology	Rinehart & Co., New York
188	Thomas S. Ruzicka	O'Hara & Osterburg	An Introduction to Criminalistics		Non-fiction	Macmillan Company, New York
189	David Stone Martin	Alan Lomax	Mister Jelly Roll		Biography	Duell, Sloan & Pearce, New York
190	Marc Simont	Marc Simont	Opera Soufflé		Non-fiction	Henry Schuman, New York
191	Arno	Malcolm Stuart Boylan	Tin Sword		Fiction	Little, Brown & Co., Boston
192	Gene Federico	Jeb Stuart	The Objector		Fiction	Doubleday & Co., Garden City, N. Y.
193	Gidon Schocken & Peter Oldenburg	Franz Kafka	Diaries 1914—23		Autobiography	Schocken Books, New York
194	Sol Immerman	Bess Furman	Washington By-line		Autobiography	Alfred A. Knopf, New York
195	Jean Carlu	Albert Camus	The Plague		Fiction	Alfred A. Knopf, New York
196	Leo Manso	Joseph Shearing	Mignonette		Fiction	Harper & Brothers, New York
197	Irving Miller	Anthony Gilbert	The Wrong Body		Fiction	Random House, New York
198	Robert Gill	Charles Calitri	Rickey		Fiction	Doubleday & Co., Garden City, N. Y.
199	George Salter	Katharine Anthony	The Lambs		Biography	Alfred A. Knopf, New York
200	George Giusti		XX Century Italian Art		Art	Museum of Modern Art, New York
201	Bill English	Cleve F. Adams	Contraband		Fiction	Alfred A. Knopf, New York
202	Roger Duvoisin	Roger Duvoisin	Petunia		Children's book	Alfred A. Knopf, New York
203	V. Lebedev			Yesterday and Today	Children's book	U. S. S. R. State Publishing Company, Moscow
204	V. Lebedev			The Circus	Children's book	U. S. S. R. State Publishing Company, Moscow
205	V. Lebedev			The Poodle	Children's book	U. S. S. R. State Publishing Company, Moscow
206	V. Lebedev			Luggage	Children's book	U. S. S. R. State Publishing Company, Moscow

Book jackets under categories see following page

Book-Jackets under Categories

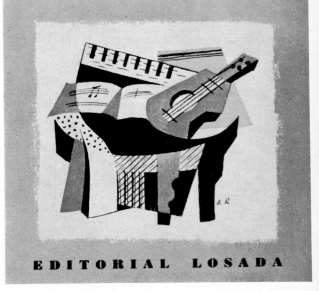

1 GORI MUNOZ

2 ATTILIO ROSSI

ARGENTINA

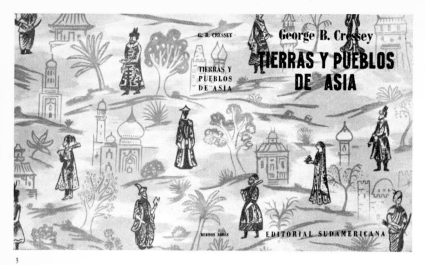

3

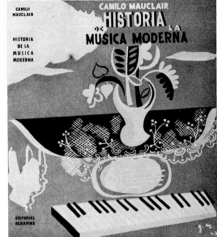

4

3 HORACIO BUTLER

4 GORI MUNOZ

5 HORACIO BUTLER

5

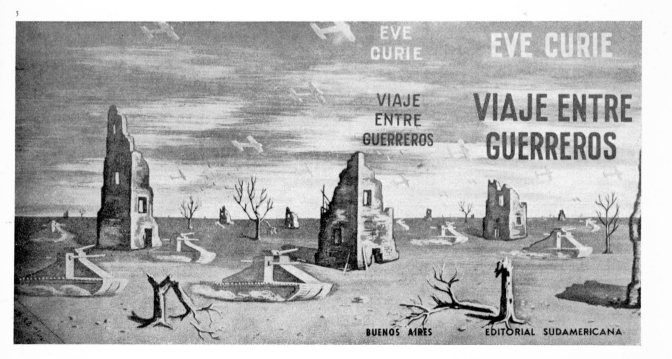

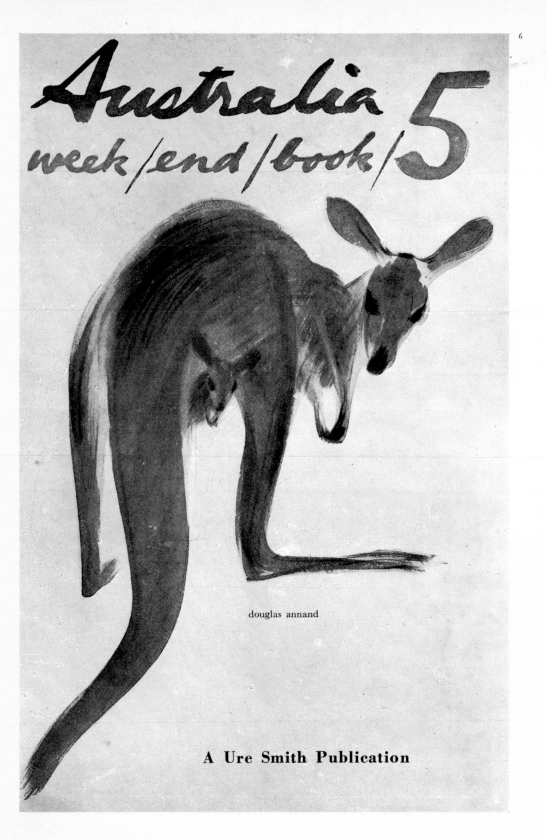

douglas annand

A Ure Smith Publication

7

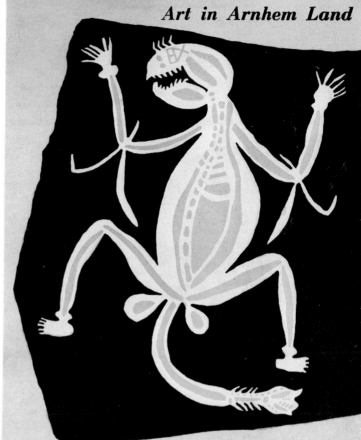

8

9

10

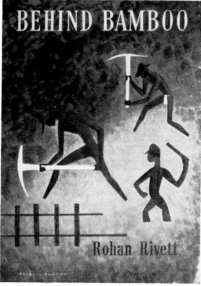

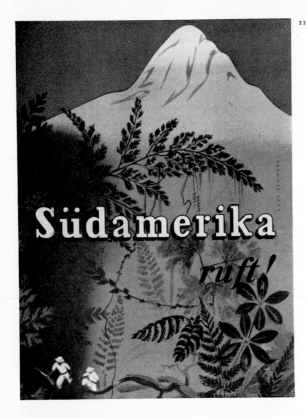

14

15

16

17

18

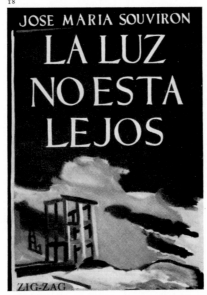

19

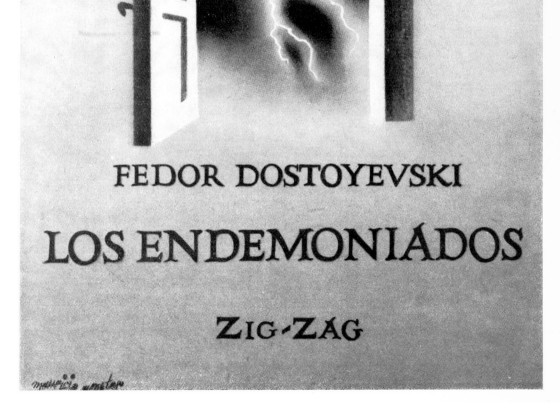

21

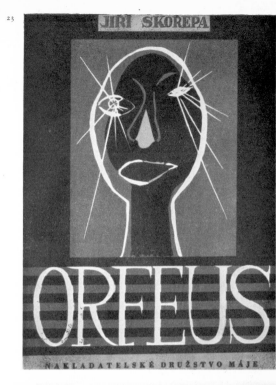

23

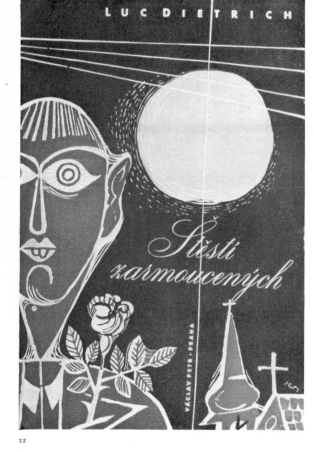

22

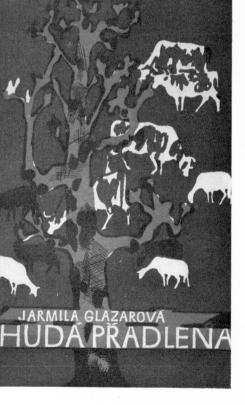

24

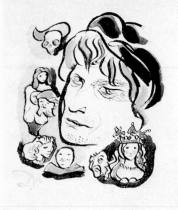

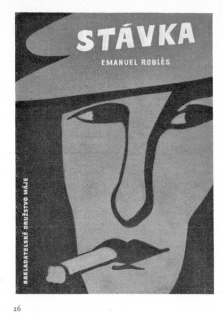

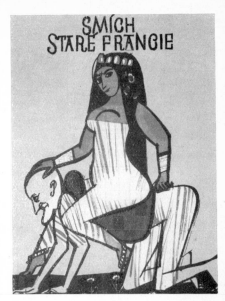

25

26

27

25 KAREL SVOLINSKY

26 JOSEF PRCHAL

27 ANTONIN STRNADEL

28 JOSEPH HOCHMAN

29 KAREL TEISSIG

28

29

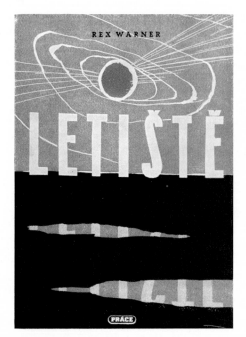

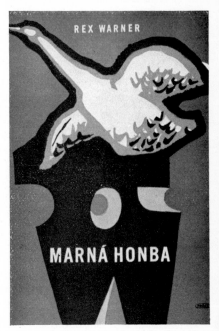

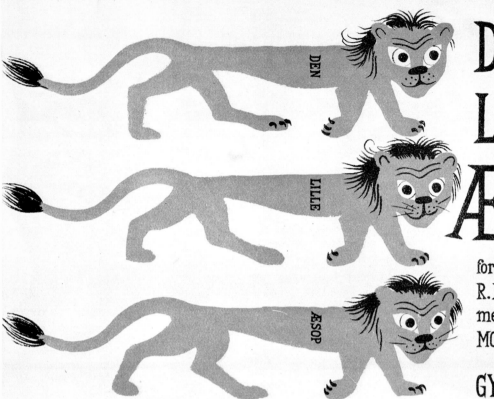

30 MØGENS ZIELER

31 MADS STAGE

30

Thoreau: Livet i Skovene (Walden)

KUNST OG KULTUR

31

32

33

14 DENMARK

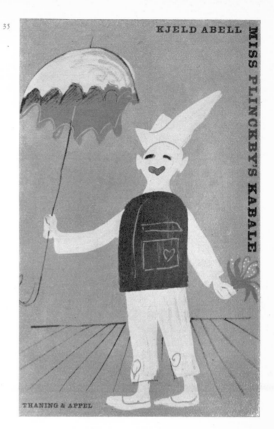

35

34

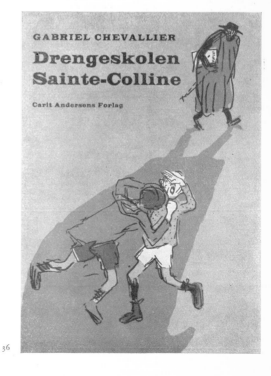

36

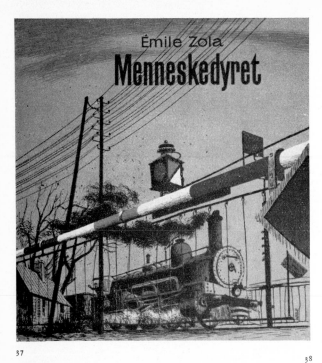

Émile Zola
Menneskedyret

37

38

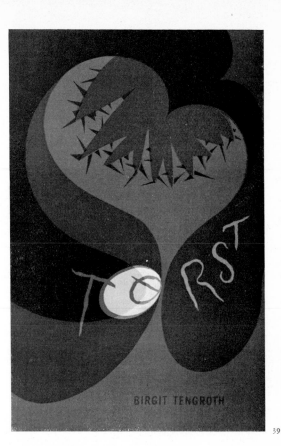

TORST

BIRGIT TENGROTH

39

PIET HEIN

VERS AF DENNE VERDEN

GYLDENDAL

ALICE GULDBRANDSEN
Hr PETIT

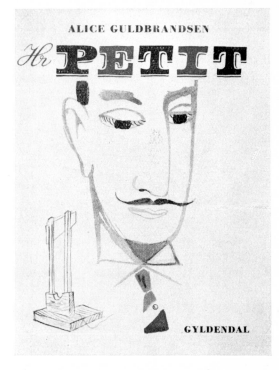

GYLDENDAL

40

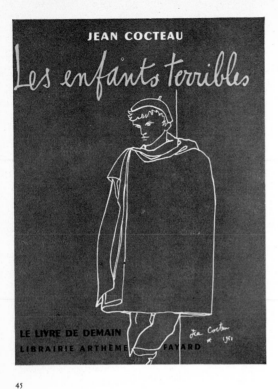

45

46

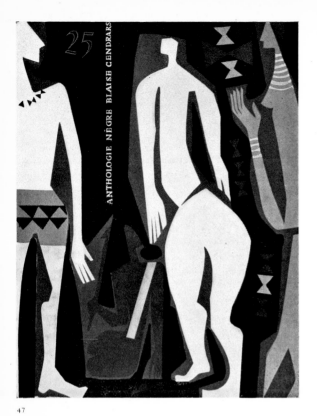

47

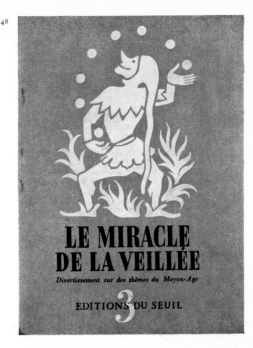

48

LE MIRACLE
DE LA VEILLÉE

Divertissement sur des thèmes du Moyen-Age

EDITIONS DU SEUIL
3

LE
LIVRE
DES
MÈRES

49

LE LYS
DE BROOKLYN

50

LE
TARoT
de Marseille

51

52

53

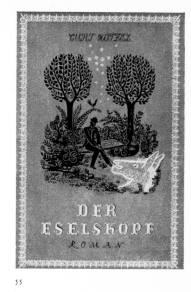

54

55

54 JOHN HEARTFIELD

55 H. KIESSLING

56 HANS HERMANN HAGEDORN

56

HEINRICH VON KLEIST

ÜBER DAS MARIONETTENTHEATER

HENRY WILLIAMSON

Die
fchönen
Jahre

S.F.V. Roman

Klaus Mann
Der
Wendepunkt
Eine Autobiographie

57 58 59

60

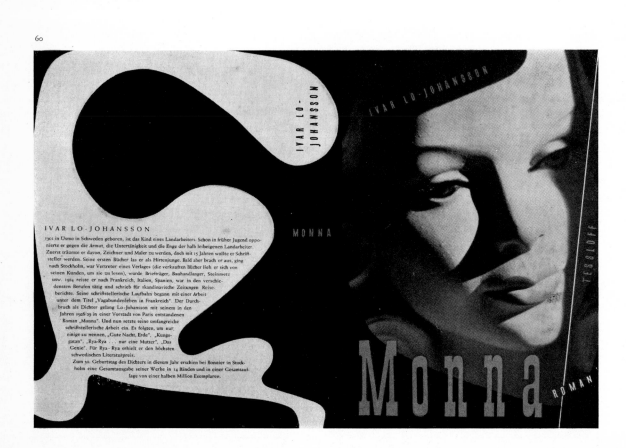

IVAR LO-JOHANSSON

1901 in Usmo in Schweden geboren, ist das Kind eines Landarbeiters. Schon in früher Jugend oppo-
nierte er gegen die Armut, die Untertänigkeit und die Enge der halb leibeigenen Landarbeiter.
Zuerst träumte er davon, Zeichner und Maler zu werden, doch mit 15 Jahren wollte er Schrift-
steller werden. Seine ersten Bücher las er als Hirtenjunge. Bald aber brach er aus, ging
nach Stockholm, war Vertreter eines Verlages (die verkauften Bücher lieh er sich von
seinen Kunden, um sie zu lesen), wurde Briefträger, Bauhandlanger, Steinmetz
usw. 1924 reiste er nach Frankreich, Italien, Spanien, war in den verschie-
densten Berufen tätig und schrieb für skandinavische Zeitungen Reise-
berichte. Seine schriftstellerische Laufbahn begann mit einer Arbeit
unter dem Titel „Vagabundenleben in Frankreich". Der Durch-
bruch als Dichter gelang Lo-Johansson mit seinem in den
Jahren 1928/29 in einer Vorstadt von Paris entstandenen
Roman „Monna". Und nun setzte seine umfangreiche
schriftstellerische Arbeit ein. Es folgten, um nur,
einige zu nennen, „Gute Nacht, Erde", „Kungs-
gatan", „Rya-Rya . . . nur eine Mutter", „Das
Genie". Für Rya-Rya erhielt er den höchsten
schwedischen Literaturpreis.
Zum 50. Geburtstag des Dichters in diesem Jahr erschien bei Bonnier in Stock-
holm eine Gesamtausgabe seiner Werke in 14 Bänden und in einer Gesamtauf-
lage von einer halben Million Exemplaren.

IVAR LO-JOHANSSON

IVAR LO-JOHANSSON

MONNA

TESSLOFF

Monna Roman

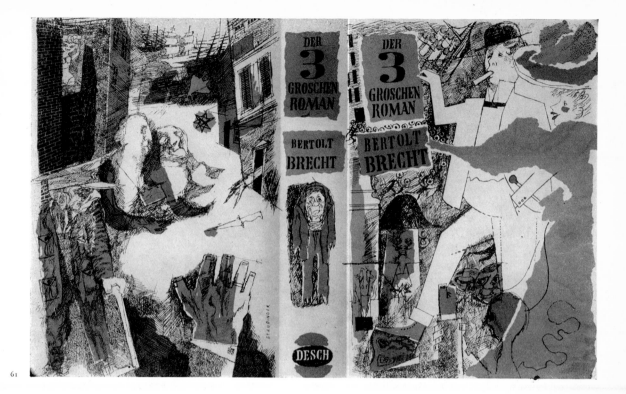

61

62

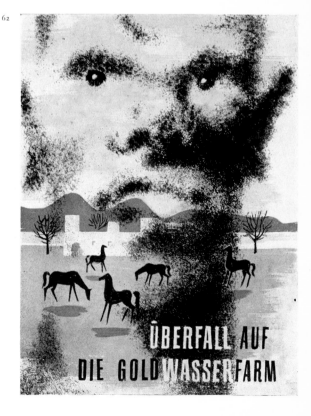

63

64

63 GERHARD C. SCHULZ

64 R. P. LITZENBURGER

65 JOHANNES BOEHLAND

66 HELMUT LORTZ

67 OSBERT LANCASTER

65

66

68

69

70

71

72
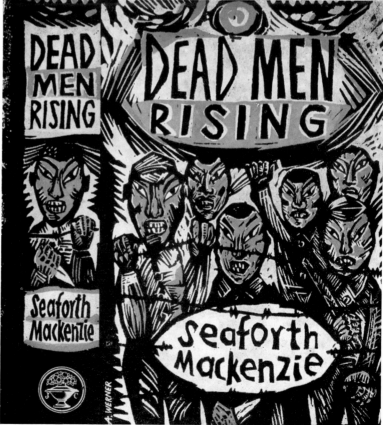

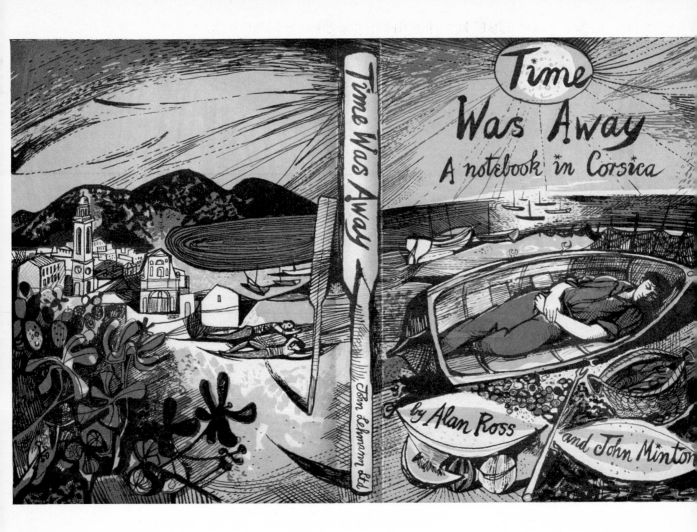

Time
Was Away
A notebook in Corsica

Time Was Away

by Alan Ross and John Minton

73 JOHN MINTON

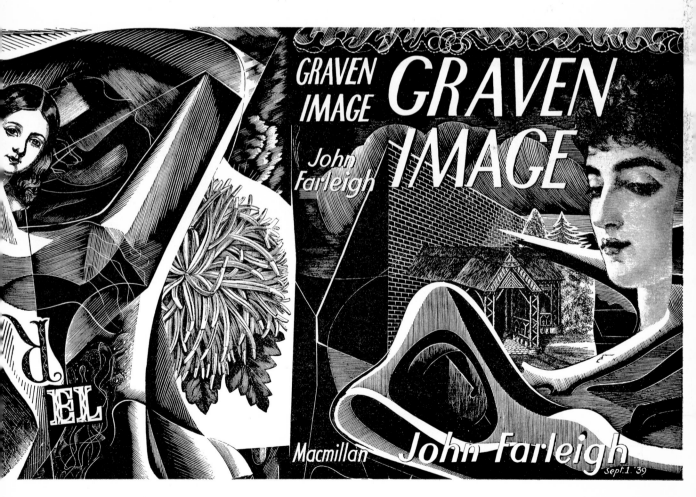

75

78

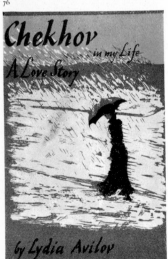

76

77

GREAT BRITAIN

79

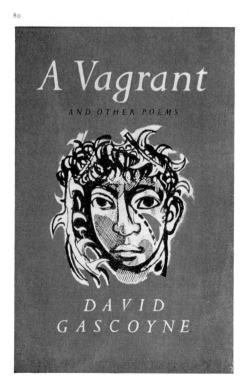

80

81

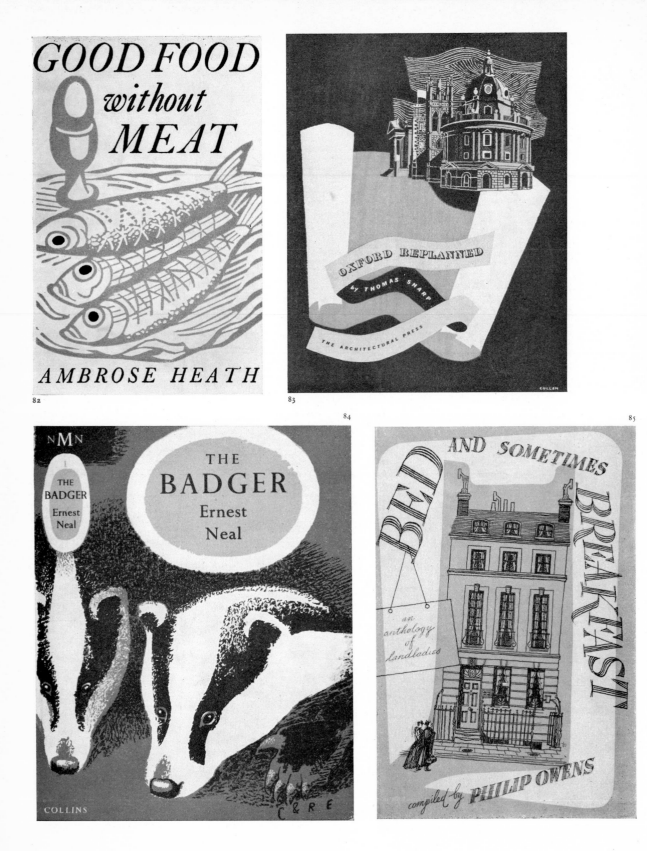

82

83

86

87

GREAT BRITAIN

33

88

89

90

91

92

93

94

GREAT BRITAIN

95

97

96

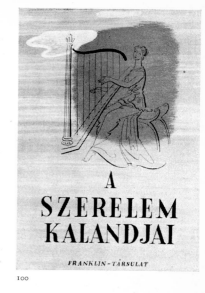

98

99

100

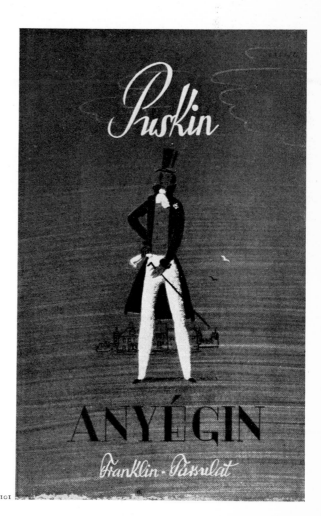

101

102

103

ד. שמעונוביץ

ספר האידיליות

ד. שמעונוביץ

ספר
האידיליות

«מסדה»

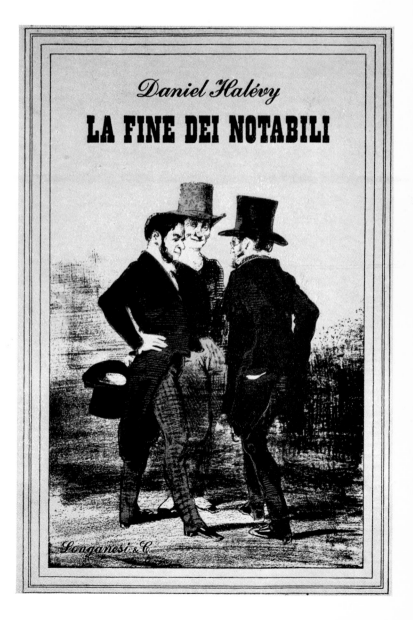

108 109 110

111

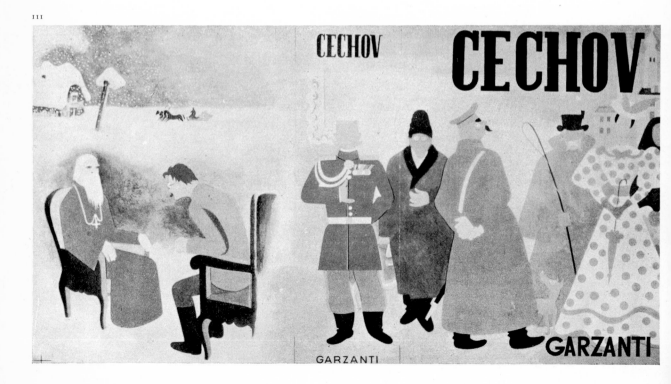

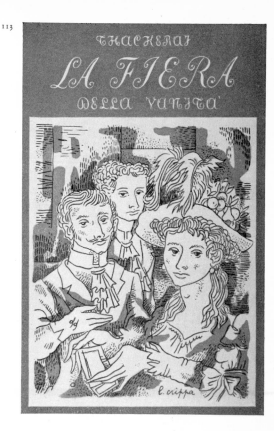

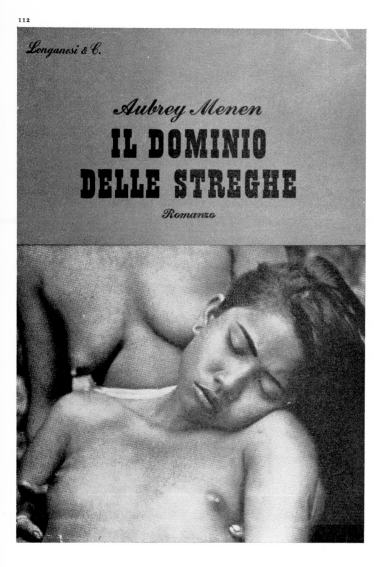

Due fratelli vivono in una stessa casa, per una stessa donna. Il romanzo è tormentoso e vivo per l'analisi delle passioni e dei sentimenti di cui soffrono implacati i due protagonisti sospesi fra cielo e terra in un paesaggio violentemente chiaroscurato e drammatico. L'opera è stata per la prima volta tradotta in italiano

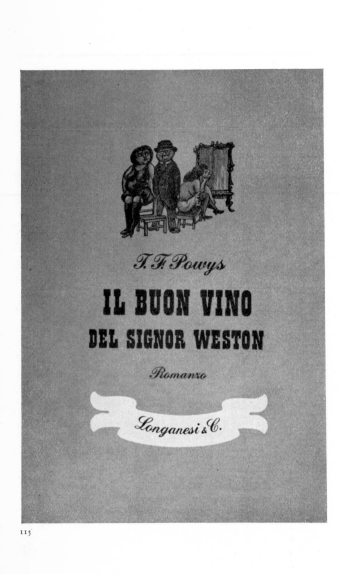

119

121

120

122

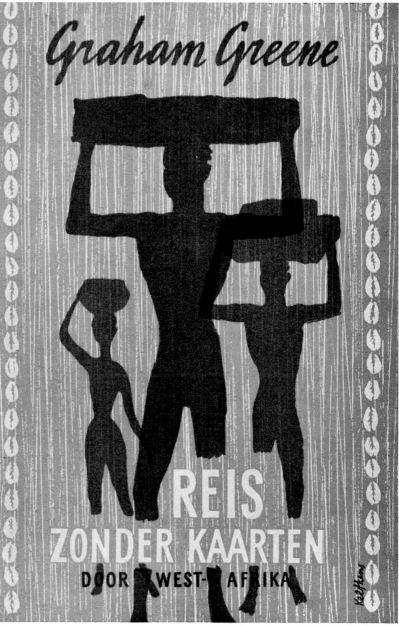

123 BERTRAM A. TH. WEIHS

124 JAN VAN KRIMPEN

125 C. J. KELFKENS

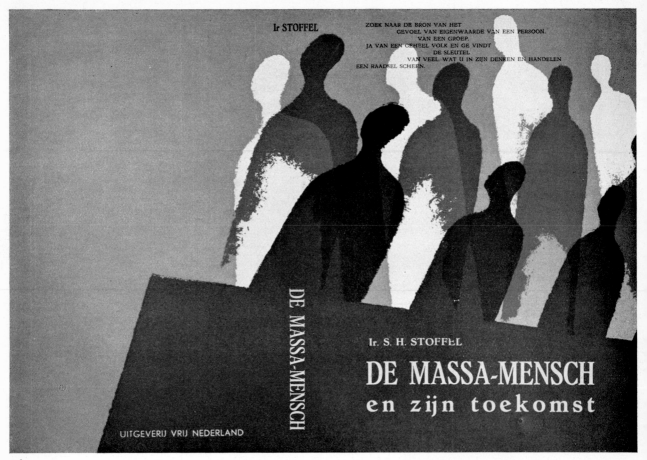

Ir STOFFEL ZOEK NAAR DE BRON VAN HET
GEVOEL VAN EIGENWAARDE VAN EEN PERSOON.
VAN EEN GROEP.
JA VAN EEN GEHEEL VOLK EN GE VINDT
DE SLEUTEL
VAN VEEL WAT U IN ZIJN DENKEN EN HANDELEN
EEN RAADSEL SCHEEN.

Ir. S. H. STOFFEL

DE MASSA-MENSCH
en zijn toekomst

DE MASSA-MENSCH

UITGEVERIJ VRIJ NEDERLAND

126

alarm

een
verhaal
voor
de jeugd
door
Paul
Bromberg

127

126 DICK ELFFERS

127 WIM BRUSSE

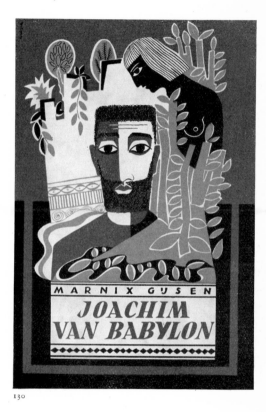

128

130

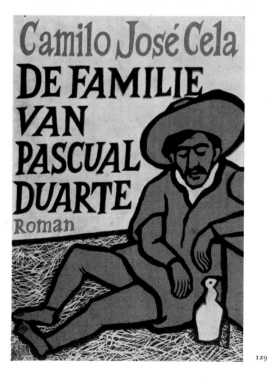

129

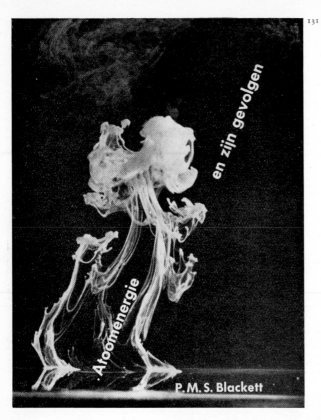

132

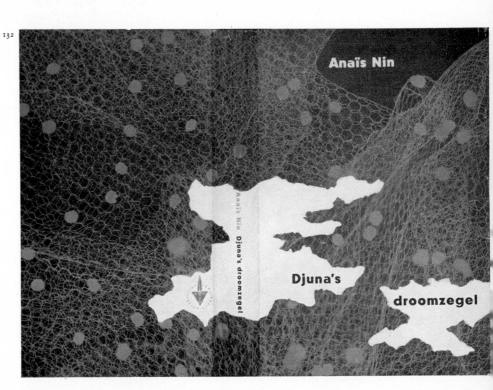

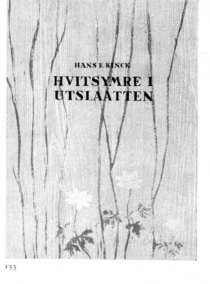

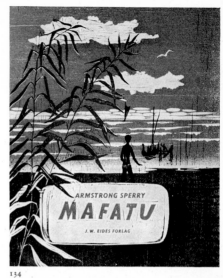

133

134

135

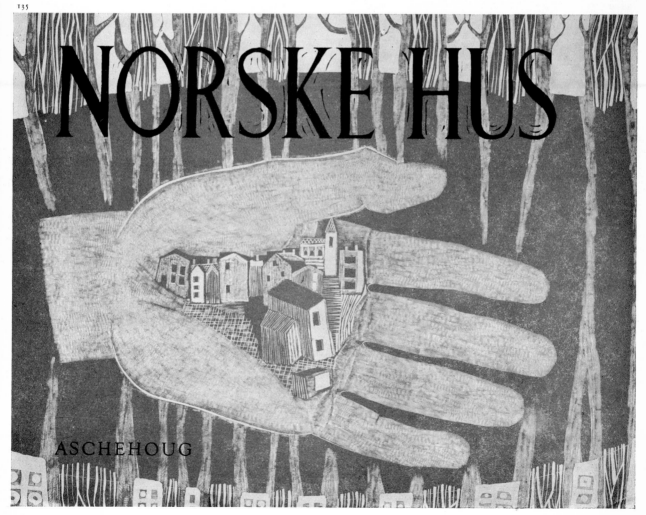

136

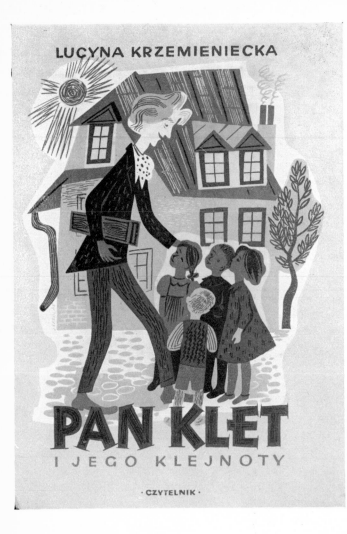

LUCYNA KRZEMIENIECKA

PAN KLET
I JEGO KLEJNOTY

· CZYTELNIK ·

137

Alicja Dryszkiewicz
ilustrował Henryk
Tomaszewski

WĘDRÓWKI PO ZWIERZYŃCU

· KSIĄŻKA ·

138

STANISŁAW JERZY LEC

ŻYCIE JEST FRASZKĄ

· KSIĄŻKA ·

139

ANIELA GRUSZECKA

W GRODZIE ŻAKÓW

· CZYTELNIK ·

140

L. PANTELEJEW i J. SOTNIK

SŁOWO
HONORU

· KSIĄŻKA ·

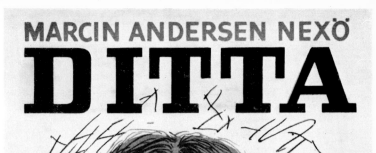

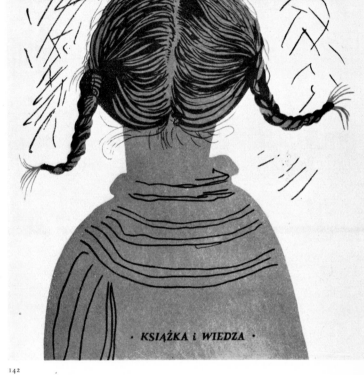

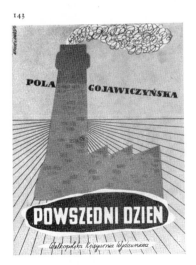

141

142

143

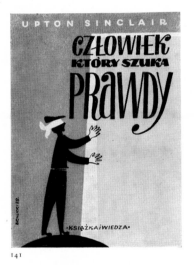

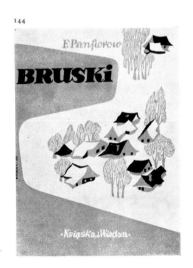

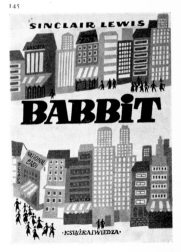

144

145

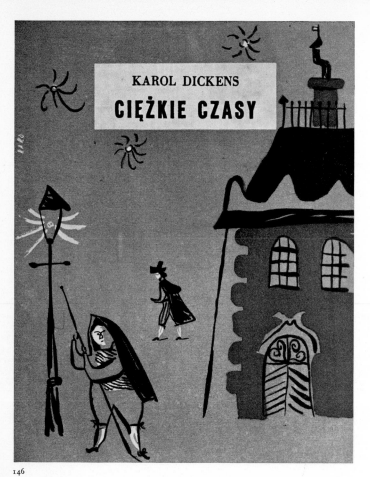

146

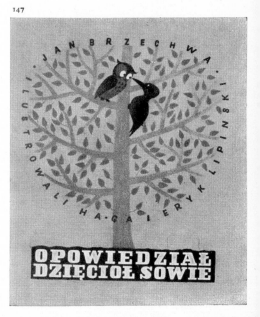

146 BARO

147 HA-GA AND ERYK LIPINSKI

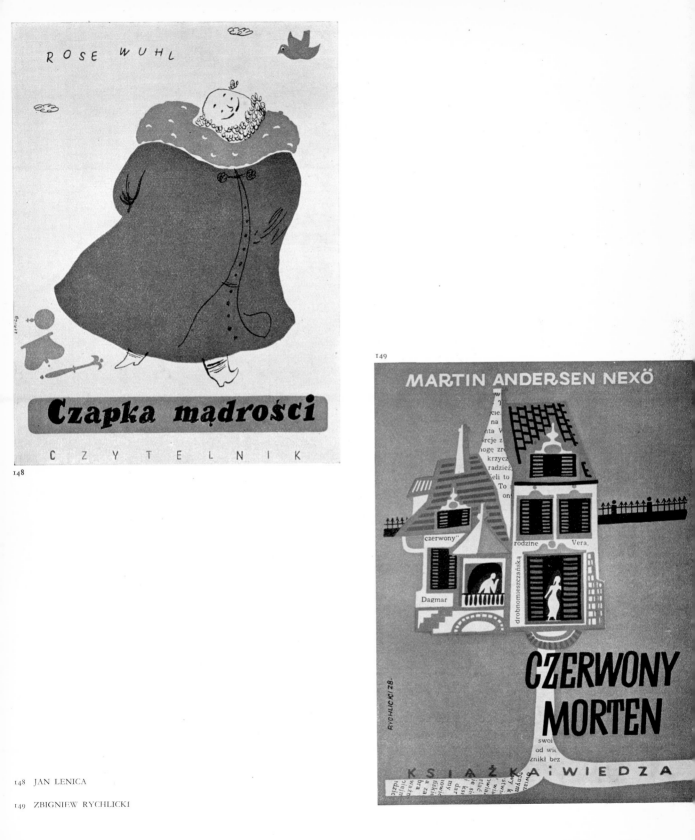

148 JAN LENICA

149 ZBIGNIEW RYCHLICKI

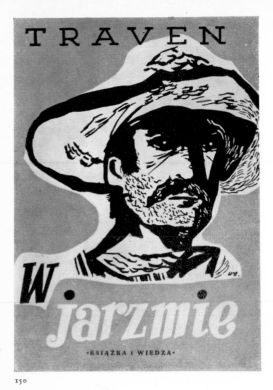

150

151

152

153

154

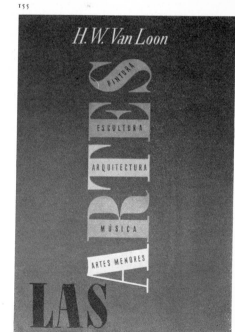

155

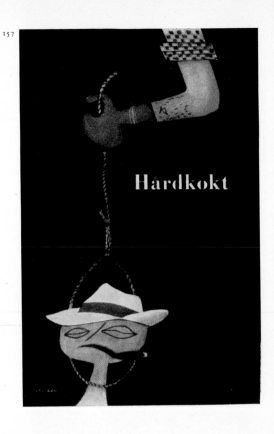

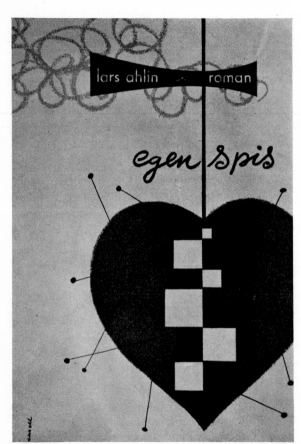

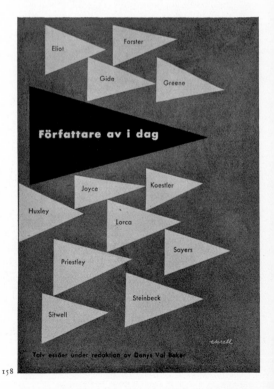

156 OLLE EKSELL

157 OLLE EKSELL

158 OLLE EKSELL

Malte Laurids Brigge

Av Rainer Maria Rilke

Ljus

159

MÖRK SÅNG

Negerlyrik i översättning av
THORSTEN JONSSON
Illustrerad av BIRGER LUNDQUIST

BONNIERS

160

159 IWAR FISCHERSTROM

160 BIRGER LUNDQUIST

161 ROBERT SESSLER

161

DER GALMISBVB

JOSEF REINHART

DER GALMISBVB
JOSEF REINHART

163

162

164

166

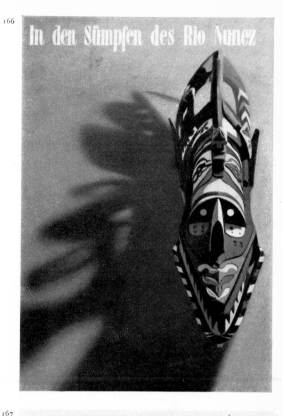

165

167

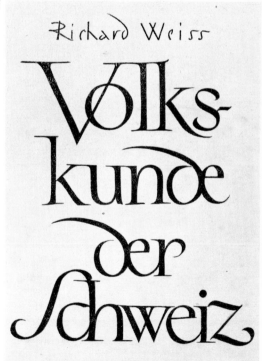

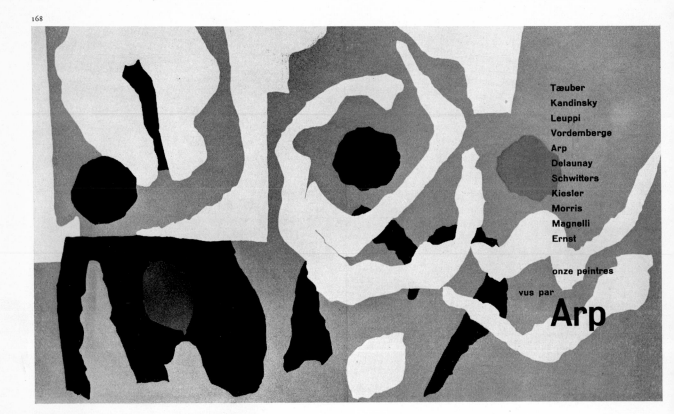

Tæuber
Kandinsky
Leuppi
Vordemberge
Arp
Delaunay
Schwitters
Kiesler
Morris
Magnelli
Ernst

onze peintres

vus par

Arp

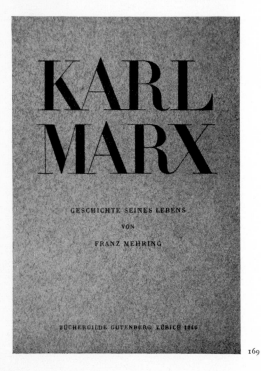

KARL
MARX

GESCHICHTE SEINES LEBENS

VON

FRANZ MEHRING

BÜCHERGILDE GUTENBERG ZÜRICH 1946

169

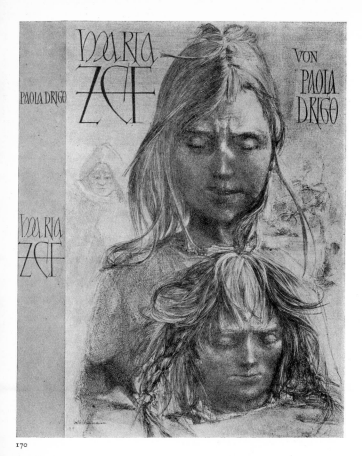

170

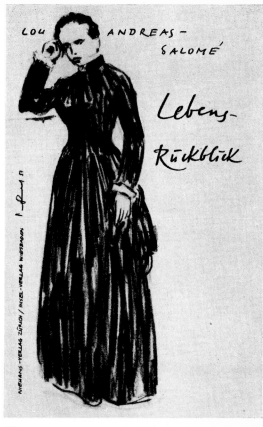

171

172

173

summer and smoke

TENNESSEE

WILLIAMS

lustig

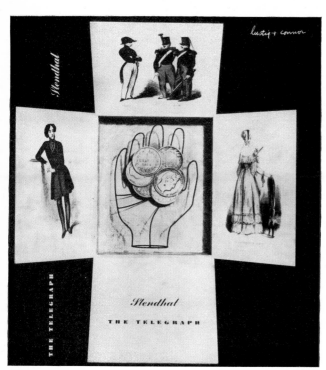

175

176

177

174 ALVIN LUSTIG

175 ALVIN LUSTIG

176 IRVING MILLER

177 DAVID STONE MARTIN

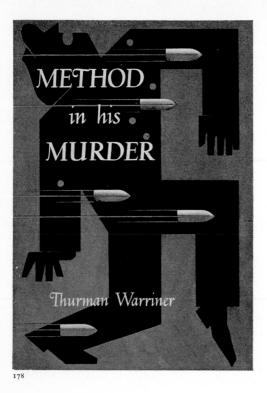

178

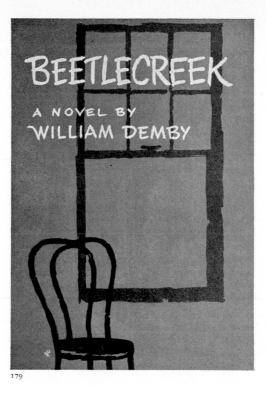

179

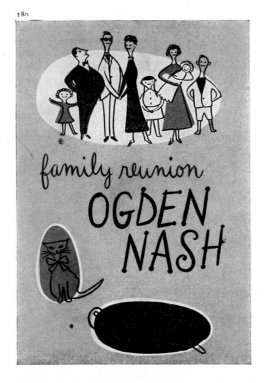

180

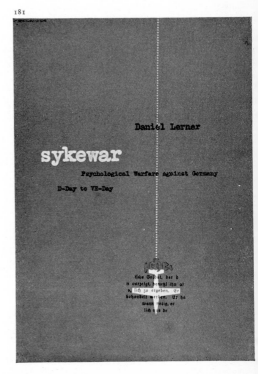

181

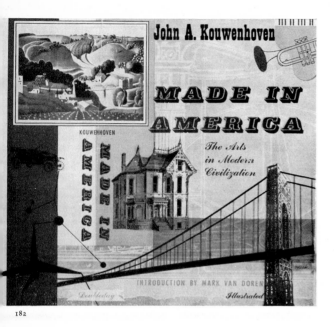

182

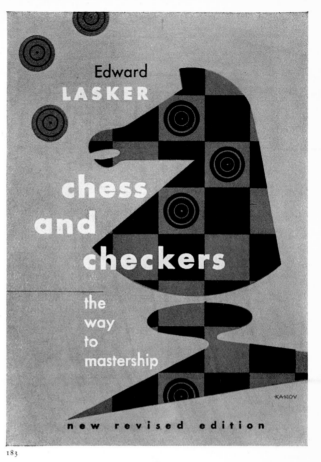

183

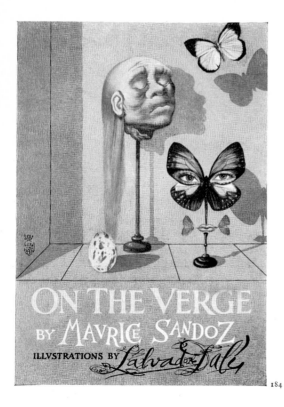

184

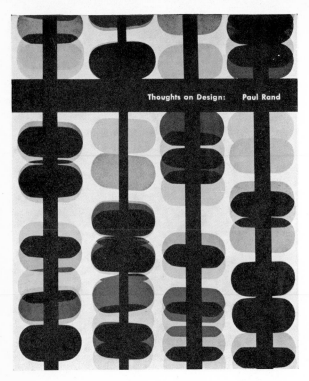

185

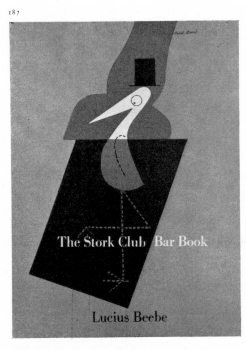

187

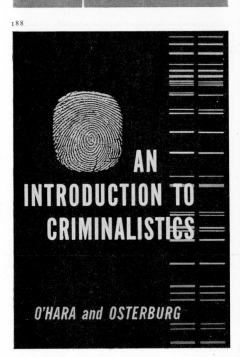

188

185 PAUL RAND

186 JOHN BEGG

187 PAUL RAND

188 THOMAS S. RUZICKA

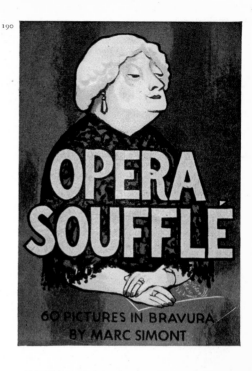

60 PICTURES IN BRAVURA
BY MARC SIMONT

189

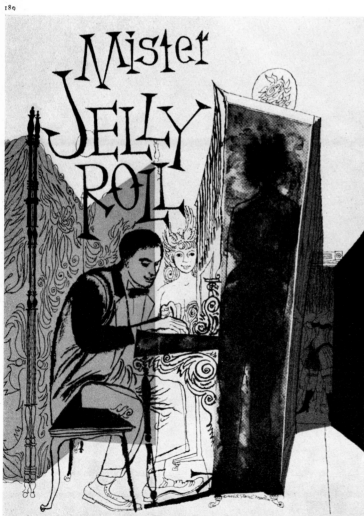

By Alan Lomax
Drawings by David Stone Martin

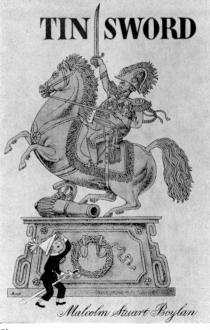

191

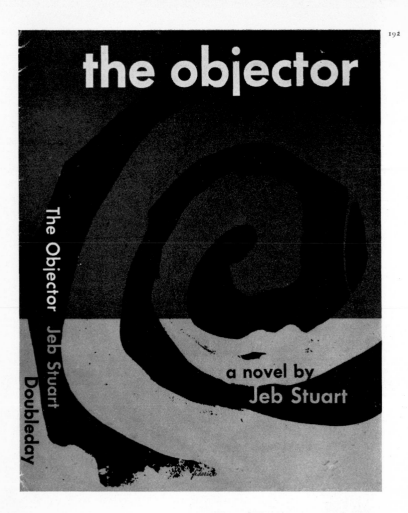

192

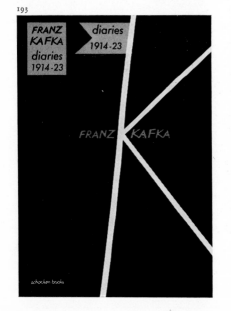

193

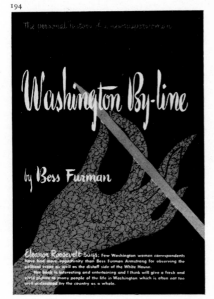

194

192 GENE FEDERICO

193 GIDON SCHOCKEN AND
 PETER OLDENBURG

194 SOL IMMERMAN

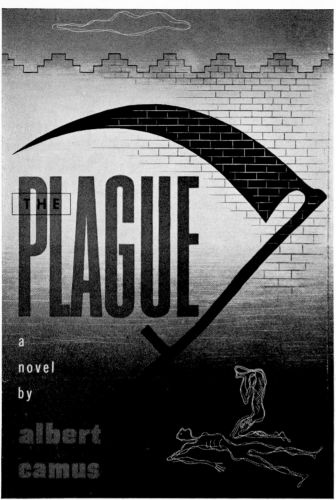

195

196

197

195 JEAN CARLU

196 LEO MANSO

197 IRVING MILLER

198

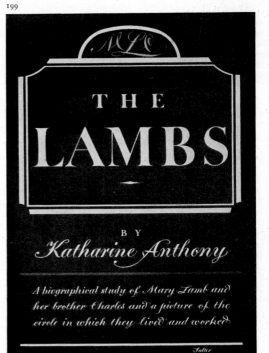

199

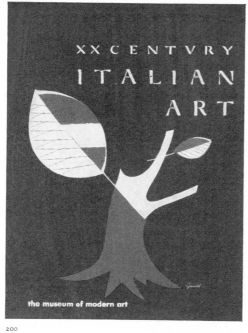

200

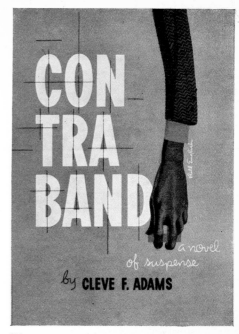

201

202

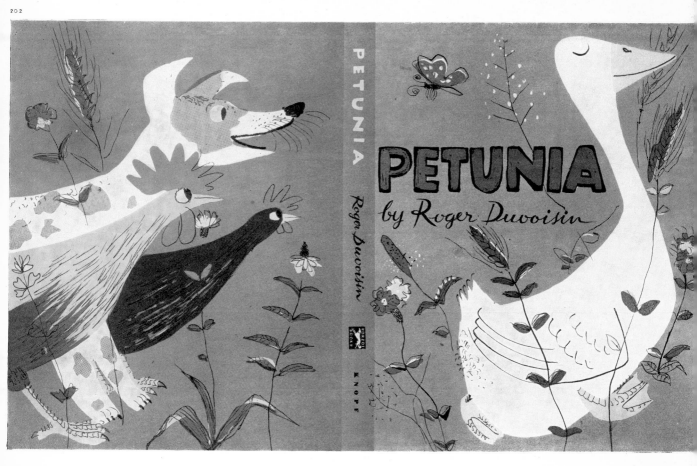

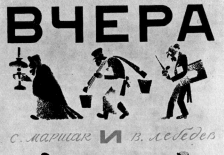

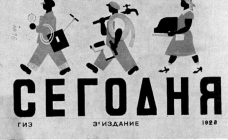

203

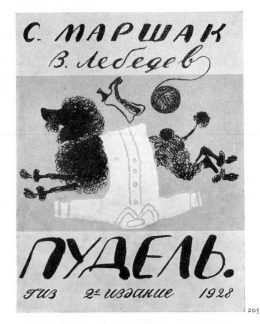

205

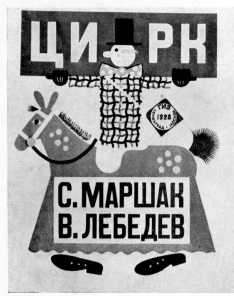

204

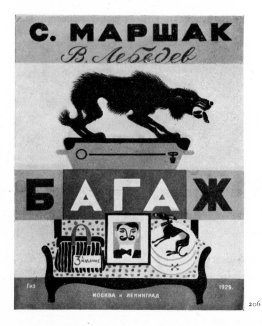

206